A Sense of Belonging to Scotland

Dedicated to the memory of Jimmy Logan

A Sense of Belonging to Scotland

The favourite places of Scottish personalities

ANDY HALL

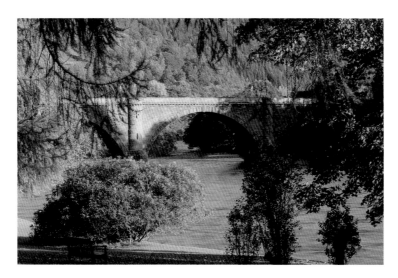

'If you stand on the bank of the river that stretches down from
the Cathedral and watch the fast-flowing river, you will see a
beauty that is timeless.'

Jimmy Logan, writing about the Tay Bridge, Dunkeld

mercatpress
www.mercatpress.com

First published in 2002 by

Mercat Press Ltd, 10 Coates Crescent, Edinburgh EH3 7AL

Reprinted 2003

ISBN 1841830364

Printed in Hong Kong through World Print Ltd

Contents

Foreword ✶ vi
Acknowledgements ✶ vii
Map of Scotland ✶ 1

Foreword

Two years before the much-heralded millennium, I made the decision to produce a photographic celebration of my home area of Kincardineshire, or The Mearns, in the North East of Scotland. Living in Stonehaven, I was very fond of the characteristic clear light of Scotland's east coast and I felt, at this historic time, when there was a tendency for introspection, that this was how I would make my personal acknowledgement of the turn of the century.

The Mearns at the Millennium was extremely well received and, unknown to me at the time, became the springboard for *A Sense of Belonging*. The Mearns book, despite being a modest publication, was an attempt to convey a part of Scotland at its most photogenic, while at the same time providing a permanent reminder for Kincardineshire folk at home and abroad.

The response to the publication far exceeded my expectations. Copies reached, one way or another, many parts of the world where Mearns exiles had relocated. I received many letters from abroad. It was clear that for people who could not be home at the dawn of the new century, there was a strong sense of longing for and belonging to this fertile parcel of land and rugged coastline in the North East of Scotland.

A Sense of Belonging is a natural progression from *The Mearns at the Millennium*, a portrayal of the emotional attachment that many Scots feel about their country. Three years on from the initial idea, I have visited and photographed parts of Scotland that, hitherto, I wouldn't have had a reason to encounter. Among them have been some gems that I feel a deep sense of gratitude to have been able to photograph in the beautiful atmospheric light that is so prevalent in Scotland. At the same time, I have had the opportunity to meet a wide range of personalities from many different fields whom I admire either personally or professionally.

Several conversations have had a significant effect on the shape of the project. On a photographic front, I contacted Scotland's principal landscape photographer, Colin Prior, to seek his thoughts on the viability of the idea. His main advice was to seek perfection in every shot, even if it meant several return journeys of hundreds of miles. I have kept this advice firmly in my mind throughout the making of *A Sense of Belonging*.

Colin's photography is inspirational to me. His first book, *Highland Wilderness* and, more recently, *Scotland: The Wild Places*, are both testimonies to his vision, imagination and skill. His encouragement and endorsement of the quality of my photography gave me the confidence in my ability to produce a collection of images of which I could be proud and which, more importantly, would reflect the feelings of affection they inspired in the personalities who were to entrust me with their support.

I also spoke at length to Jack Webster, the eminent writer and journalist, whose work I admire greatly. Jack felt that the idea had considerable merit and was definitely worth exploring further. He immediately offered his own choice of the Garden of Buchan and gave me contact details for several other people. Helped by Jack's experience of producing successful books, particularly his wonderful autobiographical account, *Grains of Truth*, I felt that with single-minded determination, I could make my dream a reality.

Over the subsequent three years and after travelling 15,000 miles, I have had some unforgettable photographic and personal experiences. In photographic terms, there are two that stand out particularly. One is the shot I took for Sally Magnusson in Mull, and the other is a day in January 2001 when I acquired three fantastic shots in one day. This was far from the norm, as most photographs needed several visits to capture the elusive and often fleeting light.

Sally wrote to me describing her place as a ruined village on the north coast of Mull, where her great-great-grandfather, on her mother's side, had lived. I had already found the collection of derelict houses, hidden in the folds of coastal fields, the previous year. I revisited the place early one August evening in 2001 with my best man from almost thirty years ago, Ricky Swan. Having avoided Highland cows en route, I set up the shot on page 3, although the sun was lowering behind a huge bank of cloud. The shot in my mind's eye was the foreground cottage, spotlit by the evening sun with the surrounding land in dappled light. All in all, it took an hour for the sun to strike the cottage in the way that I had hoped. When it eventually happened, my feelings of elation and relief were indescribable. I was pleased that Ricky was with me to help alleviate my frustration at the light constantly looking as if it would perform and then changing at the last minute, but also that he experienced the magical two-minute spell when all the elements came together in perfect union. We could feel the community from the nineteenth century moving about their daily lives. Sally describes it beautifully. To share that moment with my oldest friend, also a very keen photographer, was something that I will never forget.

A day in January 2001 also stands out in my memory. Having done my homework the previous summer for Ally McCoist's favourite place of Glencoe, I thought that the best shot would be of Buachialle Etive Mor in winter with the Coupall River in the foreground. Ally had given me free rein by saying anywhere in Glencoe would be suitable as it was all beautiful. Having phoned the Ballachulish hostel to check the snow level, and with a good weather forecast, I set off from work on the Friday, hoping against hope that I would get the shot before I would have to return on the Sunday.

Unable to settle that first night, I woke in the early hours and looked out to see full moonlight. I hastily dressed and drove up through Glencoe with the snow-covered mountains clearly illuminated by the moon. Halfway up the glen, I got out of the car to experience the atmosphere. Glencoe at the best of times is well named 'The Glen of Weeping', because of the tragic story of the Massacre of Glencoe, but in snow by moonlight it takes on an otherworldly, silent dimension which was extremely moving to experience.

When I arrived at my position about an hour before sunrise, everything was perfect. The Coupall was frozen and the waterfall was in full flow, dashing through the ice and rocks. The summit was beginning to be lit by predawn light and the moon was in the ideal position. The photograph on page 31 is the result. The only things missing are the complete silence and the intensity of the cold. It was a complete sensory experience that will always remain in my memory.

Having set aside the whole weekend, I now had the shot I wanted by 7.30 on the Saturday morning! I decided to head for Arisaig and do some information-gathering for a future trip, little knowing that I would get two more wonderful shots by the end of the day, Camusdarach Beach for Malky McCormick and Loch Morar for Sir Cameron Mackintosh.

When I eventually arrived in Camusdarach—location for the Bill Forsyth film, *Local Hero*—that January afternoon, the lighting conditions were perfect and I got a lovely shot, looking back towards Sgurr na Ciche.

I was delighted to have managed two beautiful images and, as the sun dipped below the horizon, I drove up the side of Loch Morar in the fading light to establish a future location for Sir Cameron Mackintosh. Having made my way to the end of the road, I turned to see the most magical afterglow light over Loch Morar. It was breathtaking and I knew that I would wait a long time before finding a better opportunity than this to convey the loch in such beautifully atmospheric light. This was the most fulfilling and unforgettable day of the whole project.

☆

In putting *A Sense of Belonging* together, my driving force has been my love of Scotland. I feel grateful to have been given the opportunity to reflect its diverse facets: pastoral and industrial, rugged and serene, viewing it as a panoramic vista or in intricate close-up, all in a variety of seasons. I am also grateful to have been given the chance to capture the essential qualities of these places through the eyes of people whom I admire so much. They are all very busy, but have taken the time to enhance the project with some wonderful writing, whether descriptive or anecdotal, often both. They represent excellence in their chosen fields and it means everything to me to have been able to open a window on their lives through *A Sense of Belonging*.

Acknowledgements

There are many people and organisations who have helped me on my journey to the final publication of *A Sense of Belonging*. I would like to take this opportunity to acknowledge and thank them for their encouragement and friendship.

Most importantly, my love and thanks go to my wife, Sylvia, who has been my constant support throughout the project. Her patience, understanding and artistic advice have been fundamental to the creation of this book.

In particular, I would like to thank Raeburn Christie (Solicitors) of Aberdeen for their financial contribution towards one of my longest trips. They have supported me since the inception of *The Mearns at the Millennium* and I am delighted to be able to thank them for their generosity and faith in my photography.

I would like to acknowledge permission from Glasgow City Council to photograph from Kelvingrove Park for Eddi Reader's place of Kelvingrove Art Gallery & Museum.

I am indebted to Niall and Jacqueline Irvine of Perspectives for the exceptional quality of their scanning work and their invaluable creative advice and to John Hutchinson of Still Digital for my black and white portrait scans.

My special thanks go to my friends at Mercat Press, in particular Seán Costello, whose insight and enthusiasm has brought my dream to reality. I wish the new Mercat Press the success they deserve.

I would finally like to pay tribute to the wonderful writing of Lewis Grassic Gibbon, particularly the novel *Sunset Song*, for instilling in me a love of Scotland's landscapes.

Andy Hall, October 2002

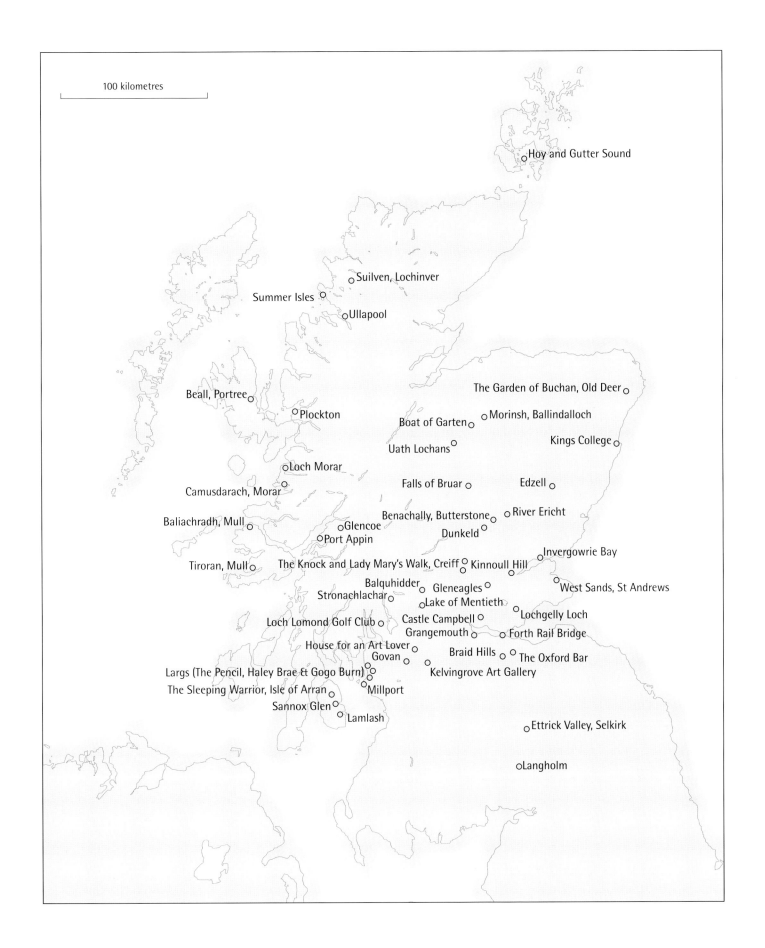

100 kilometres

Hoy and Gutter Sound

Suilven, Lochinver

Summer Isles

Ullapool

The Garden of Buchan, Old Deer

Beall, Portree

Morinsh, Ballindalloch

Plockton

Boat of Garten

Kings College

Uath Lochans

Loch Morar

Falls of Bruar

Edzell

Camusdarach, Morar

Benachally, Butterstone

River Ericht

Baliachradh, Mull

Glencoe

Dunkeld

Port Appin

Invergowrie Bay

Tiroran, Mull

The Knock and Lady Mary's Walk, Creiff

Kinnoull Hill

West Sands, St Andrews

Balquhidder

Gleneagles

Stronachlachar

Lake of Mentieth

Lochgelly Loch

Loch Lomond Golf Club

Castle Campbell

Forth Rail Bridge

Grangemouth

House for an Art Lover

Braid Hills

The Oxford Bar

Govan

Largs (The Pencil, Haley Brae & Gogo Burn)

Kelvingrove Art Gallery

The Sleeping Warrior, Isle of Arran

Millport

Sannox Glen

Ettrick Valley, Selkirk

Lamlash

Langholm

Baliachradh, Isle of Mull
The favourite place of Sally Magnusson

I discovered Baliachradh when I was hunting for the township where my people came from on Mull. It was where my great-great-grandfather, James McKechnie, spent his early life, one of those sad and empty places you find all over Mull, relics of a lost community.

When I found it, I thought Baliachradh was one of the most enchanting places that I had ever seen. As the photograph suggests so translucently, it's not majestic, or breathtaking, or even wild and desolate in the way of Scotland's most striking landscapes, but rather touchingly domestic.

With its scattering of ruined stone houses arranged around kiln and grazing land, its once-neat vegetable patches, its shelter from the sea which glints just beyond the hill, Baliachradh felt overwhelmingly homely. It still feels a bit like home.

Sally Magnusson

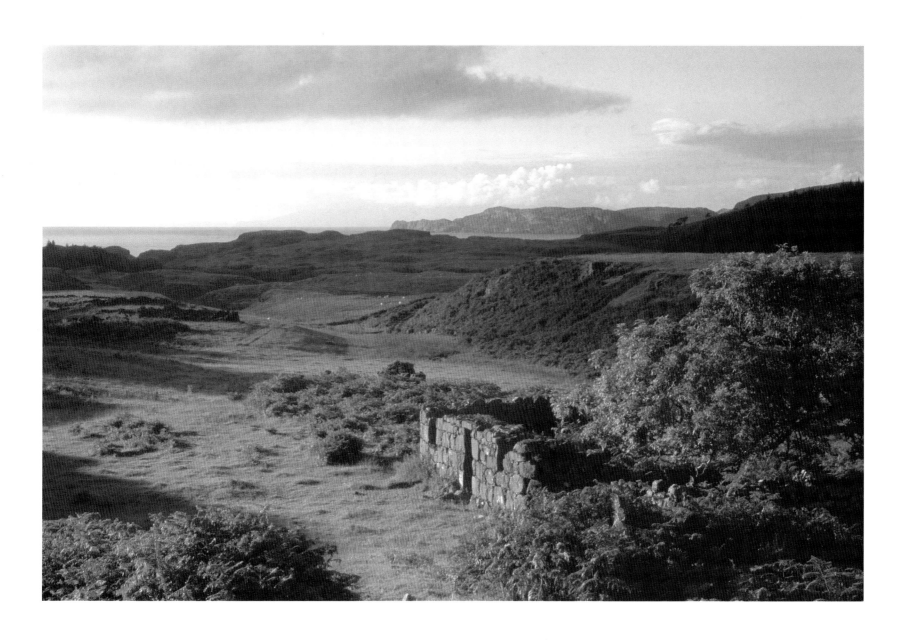

Balquhidder and Loch Voil, the Trossachs
The favourite place of Hannah Gordon

The first time I visited Balquhidder was on a freezing, damp and foggy November day in 1987. I had come with my brother to view a cottage overlooking Loch Voil. It was virtually derelict, uninhabited for the previous five years, and badly in need of a new roof, a damp course, and much more. I couldn't wait to get my hands on it! About fourteen months later it was my pride and joy, and nothing will ever surpass the pleasure of bringing it to life.

Balquhidder is a well-known beauty spot and remains steadfastly unspoiled. It 'enjoys' a far above average rainfall, and one old lady, on hearing where my cottage was, remarked, 'Oh, aye, I know it well. Rain and midges!' But to me it is one of the most special places in Scotland. On a calm and sunlit day it takes your breath away; the loch like glass, the grandeur of the hills, the utter stillness and tranquillity. I have seen more stars here on a clear night than almost anywhere else, and marvelled at its beauty in winter…

I could go on, but I think by now you've got the message. Besides, Andy's photograph says it all.

Hannah Gordon

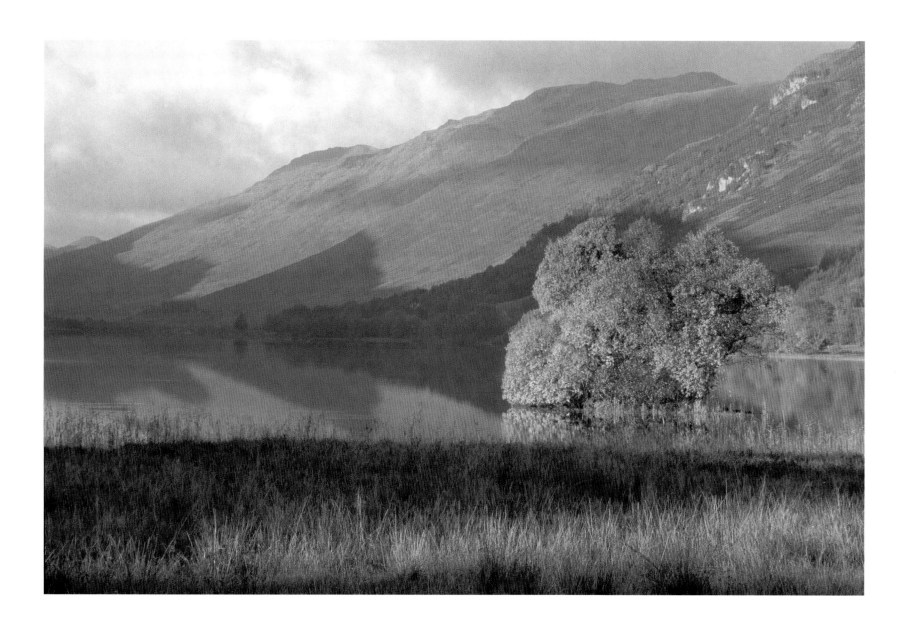

Beall, Portree, Isle of Skye

The favourite place of Donnie Munro

There are many places that we encounter on our travels which leave a deep and lasting impression on our minds. Amidst the excitement of the discovery of the new, it has always been important for me to return to that space where you feel utterly connected. A part, if you like, of something which simply is.

For me that place has always been Beall, just a short walk from my family home in Scorrybreac. Here the boulder-strewn landscape folds out onto the rolling green 'flats', running gently upwards to the high headland overlooking the Sound of Raasay and beyond to the hills of Wester Ross.

Here in the stillness of time is a settled feel, of all that has gone before, and a sense of scale that seems, at least for a moment, to make sense of all things.

Donnie Munro

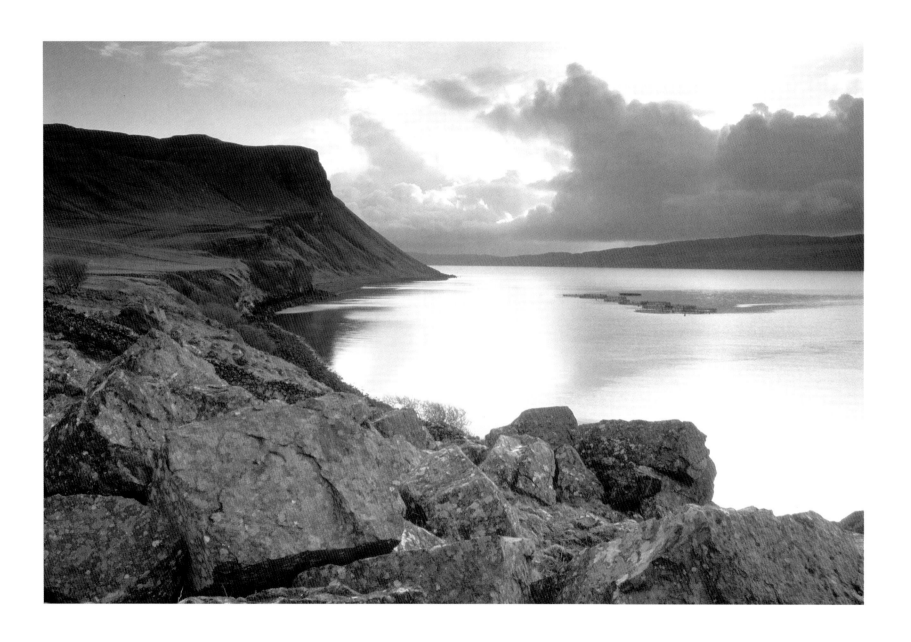

Benachally, Butterstone, Perthshire

The favourite place of Dougie MacLean

Above my house in Butterstone is a hill called Benachally. On top is a beautiful stone cairn. It looks out over Strathmore to the south and the Grampians to the north, two very distinctive landscapes. Over the years, I have spent a lot of time there with my family—grandparents, parents, uncles and my own children. It has been so often the place to aim for on picnics and walks with three generations of MacLeans. I have a photo of my mother as a young woman standing on top of the cairn.

The hill can be seen from some distance away, and on returning from long concert tours I knew that when Benachally came into view I was almost home! Andy Hall's beautiful photograph captures so well my feeling of affection for this very special place.

Dougie MacLean

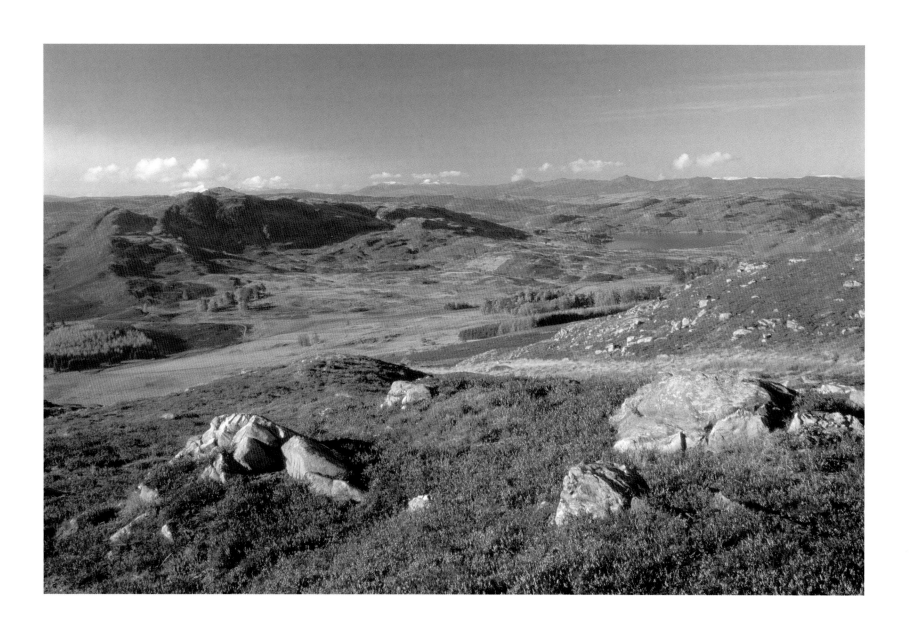

Boat of Garten Golf Club, Strathspey

The favourite place of Gavin Hastings

Boat of Garten Golf Club is certainly one of Scotland's 'Hidden Gems' and I would challenge anyone not to be inspired by the wonderful views and sheer beauty of the place.

Although it would be impossible to play golf when this photograph was shot, it does capture the peacefulness and clarity of this part of Scotland which makes playing golf here such a memorable experience.

It doesn't take long for any visitor to feel welcome and at home when you are this close to nature.

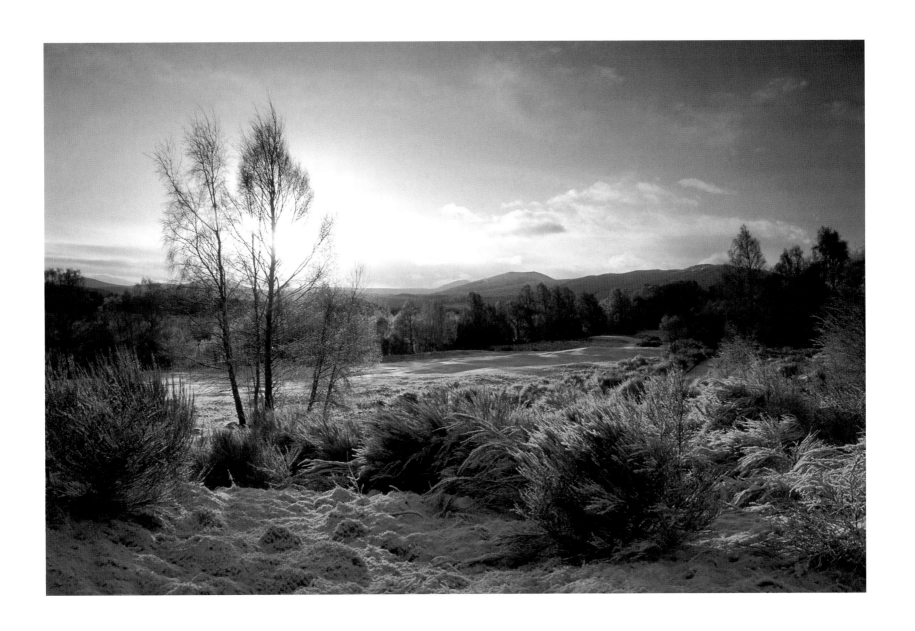

Camusdarach, Morar, Lochaber

The favourite place of Malky McCormick

Many years ago, I set up my tent overlooking a small bay on the north-west coast of Scotland. Ever since then, my family and I regularly visit its beauty, always under canvas.

Now, when I reveal my favourite location, please don't all rush there at once! Camusdarach is a beach south of Morar, north of Arisaig. Meaning in Gaelic 'Bay of the Oaks', it is hidden from the Mallaig road by those very trees.

With the islands of Rum, Eigg, and Skye behind, look towards the bay's white sands as they climb to the spectacular sand dunes, topped with yellow broom. Eastwards, the snow-capped mountains of Lochaber are dominated by Sgurr na Ciche, a perfect conical peak.

To walk barefoot on the shore of Camusdarach is heaven on earth… with its own unique aroma.

I swam there, one summer's evening, with two seals. Even sitting in my Ayrshire studio, penning this picture of Camusdarach, I long to be there. I simply love it.

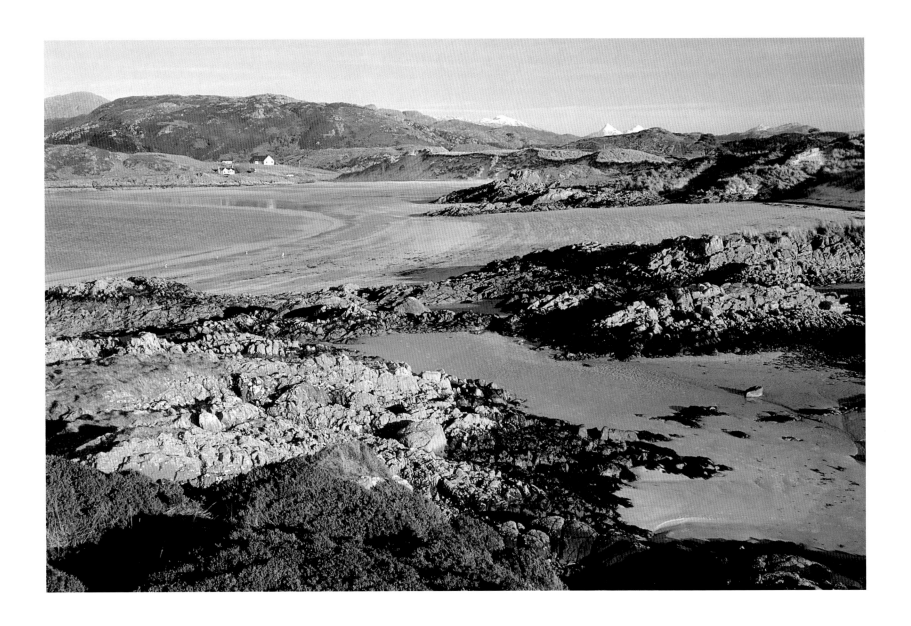

Castle Campbell, Dollar Glen, Clackmannanshire

The favourite place of Barbara Dickson

This picture is beautiful and captures the lonely grandeur of Dollar Glen. I have loved Castle Campbell since I was a child in Dunfermline; we used occasionally to go to the Hillfoots as a treat, although my father had no car.

My dearest friend, Yvonne Kirkus, was the custodian of the place for many years and tramped those hills for most of her time there. Dollar Glen is truly beautiful, without being inaccessible. You don't have to drive for hours from anywhere central to enjoy its charms.

My children now look on Castle Campbell as a very special place too. Born in London and raised in England, they were reminded of half of their own heritage when we visited Yvonne.

Sadly she retired last year. I'll just have to buy a castle now!

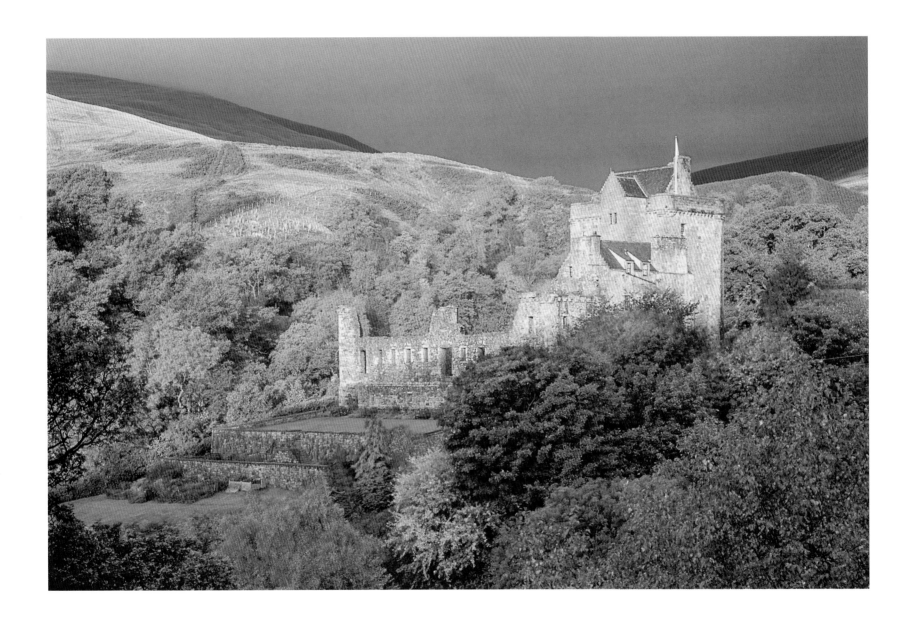

Dunkeld, Perthshire
The favourite place of Jimmy Logan

This lovely photograph is of the ancient bridge at Dunkeld. If you stand on the banks of the river that stretches down from the Cathedral and watch the fast flowing river, you will see a beauty that is timeless.

If you cross this ancient bridge and walk down the bank at the other side by the Old Toll House, you come to Birnam Woods, mentioned by William Shakespeare. Apart from the beauty of the trees, the sound of the water as it dances round the stones on the shore is a melody that has never been captured by man.

For the South African War, the Duke of Atholl raised a regiment and called it the Scottish Horse. Dunkeld is its Regimental Headquarters and I can hear the horses crossing this bridge in 1914 on their way to the war that was to end all wars.

My father spent his life in theatre, but as a young man he was called up and, because he loved horses and the smart uniform, he joined the Scottish Horse. In January 1918, he was wounded and had to have his right leg amputated. Fifty years later, when we visited Dunkeld, he pointed out the river where he was confined to barracks for three days for swimming in the fast tide against orders. He even remembered the house in the village where he was billeted as a young soldier paying 1s. 6d. a week. As I walk in Dunkeld to this day, my father is by my side as he was before a bit of shrapnel changed his life.

This photograph captures much of the special beauty and peace to be found there and as the spring changes to autumn and the colour of the trees from summer to autumn gold, I hope it makes you want to go and see its beauty for yourself.

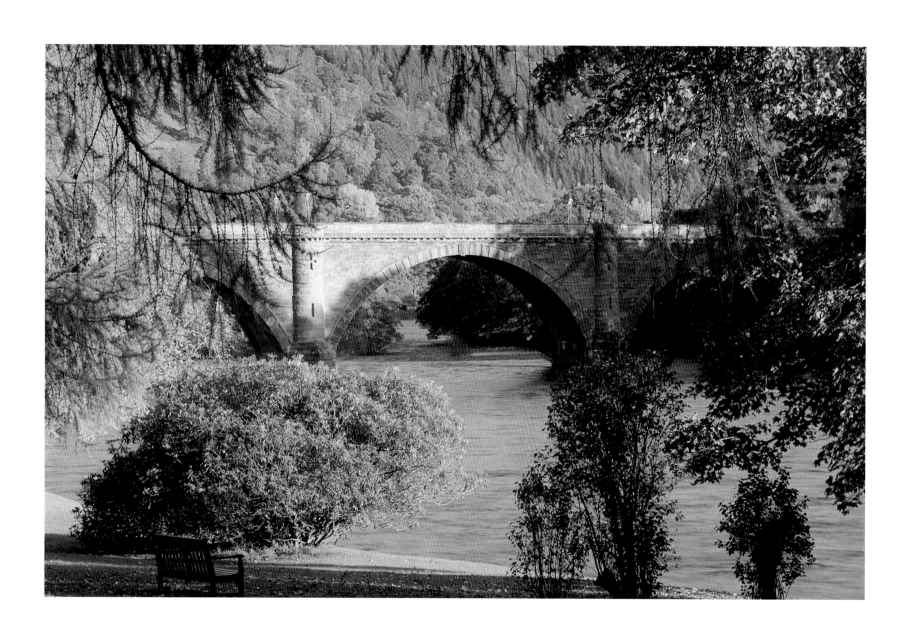

Edinburgh from the Braid Hills

The favourite place of Ronnie Corbett

Between the ages of perhaps seven and twelve, every Sunday after lunch and morning kirk, my dad would take us—Allan, my brother, and sister Maggie—on a walk that would take in this view. He knew the route well because he was a member of the Harrison, attached to the Braids, and as a night baker probably played the course at quiet times off a handicap of three or four, so he was pretty good, certainly better than me.

No golfers on the course on a Sunday in those days but it is nice to see them in the picture now.

We would give Mum a break to put her feet up and we would walk up the Fairmilehead side, right across the Braid Hills and down the Liberton side to and from Marchmont Road. It is quite a distance when I drive it now. When we returned home fresh-faced and rosy-cheeked, we would have a delicious tea, Welsh Rarebit as only Mum could make it. She had a clever way of doing it and it turned out like a very cheesy, beautifully scrambled egg. We would then enjoy toast with homemade raspberry jam, quite delicious. Then Dad was off to the evening service at the church—on his own, I'm afraid.

Ronnie Corbett

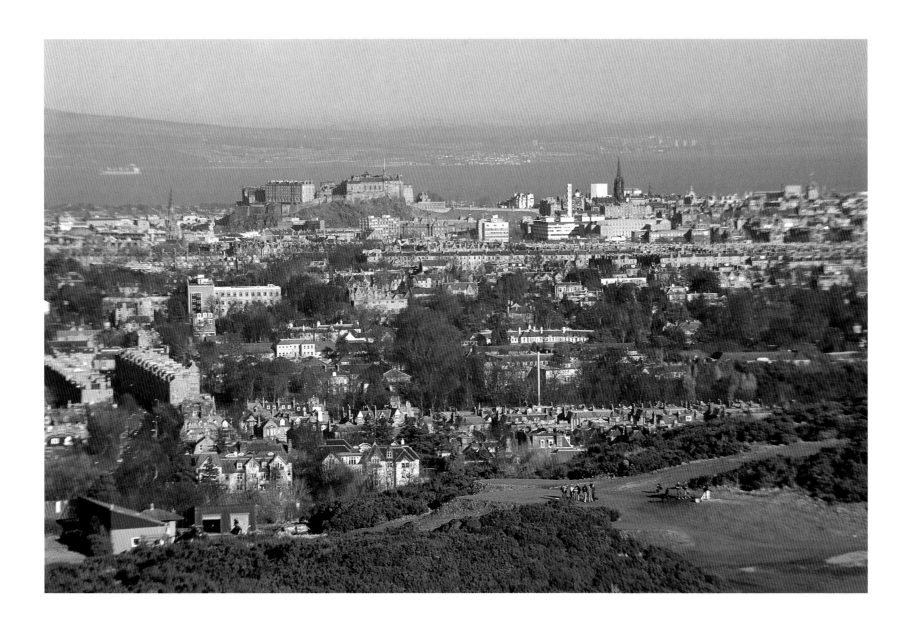

Edzell, Angus

The favourite place of Bob Crampsey

Scottish villages as a rule tend to be workmanlike rather than beautiful, but now and again one comes along which manages to combine both qualities.

Such a one is Edzell, which impinges on the visitor at about a mile's distance from the Brechin side. Through a forest, round a bend and suddenly there is the triumphal arch guarding the entrance to Dalhousie's village.

The overwhelming impression is of spaciousness; the 'Glennie' (the Glenesk Hotel), sits back from the road as does the Inglis Memorial Hall on the other side, scene of many a keenly-fought badminton match against such as the Coventry Tool Works from that same Brechin. I hear the ghostly shuttles flying through the air but also the local Operatic Society who seemed always to prefer *The Arcadians* or *The Maid of the Mountains* to the latest Broadway success.

The golf course is one of Scotland's sleeping giants, beautiful beyond words with many glorious views of the Angus glens to compensate for the foozled shot. The breadth of the streets makes Edzell a relaxing place and if the wind is off the hills, it makes one realise that for much of the year one does not breathe air within the meaning of the act.

Down the lane that runs alongside the Post Office is the Shakkin' Brig, which moves just enough to lead to the odd uneasy thought. I have abundant memories of the place. The year of 1955 crowds in, when it did not rain in those parts from Whit Monday until almost early September. The salmon could be lifted from the North Esk, had they been worth the lifting.

I like to think I played a small part in the destiny of the village. I was up at the 'drome when we handed over to the Americans.

I played football all over the Mearns. It remains my favourite part of Scotland and I thought the very least was to take my wife there on our honeymoon. Short of 'buying the company' there was nothing more I could do. I still go back; I still find it an enchanted place.

Bob Crampsey

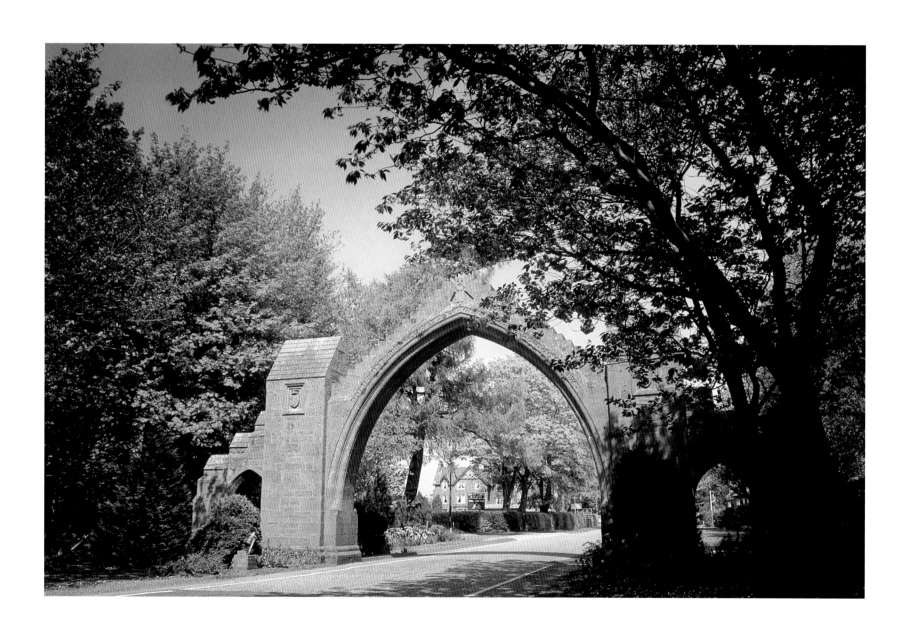

Ettrick Valley, Selkirk, the Borders

The favourite place of Sir David Steel

The Ettrick Valley is over twenty miles long from its top at Potburn Farm to the point where the Ettrick Water joins the Tweed outside the Royal and Ancient Burgh of Selkirk. My home has been in this beautiful valley, with its upland rugged hills of trees and heather to its low-lying pastures, since 1966.

The valley was the home of James Hogg, the Ettrick Shepherd, whose words and poetry are currently enjoying a renaissance. His grave is in Ettrick Churchyard, only hundreds of yards from where he was born.

My current home is only four miles up the valley from Selkirk, in the now restored Aikwood Tower (later anglicised by Sir Walter Scott and others to 'Oakwood'), built in the late sixteenth century. In the byre attached to the tower we currently house the James Hogg Museum.

The stretch of the Ettrick in this photograph is the town's water where, in common with other members of the Selkirk and District Angling Association, I cast an occasional optimistic fly over an ungrateful salmon.

David Steel

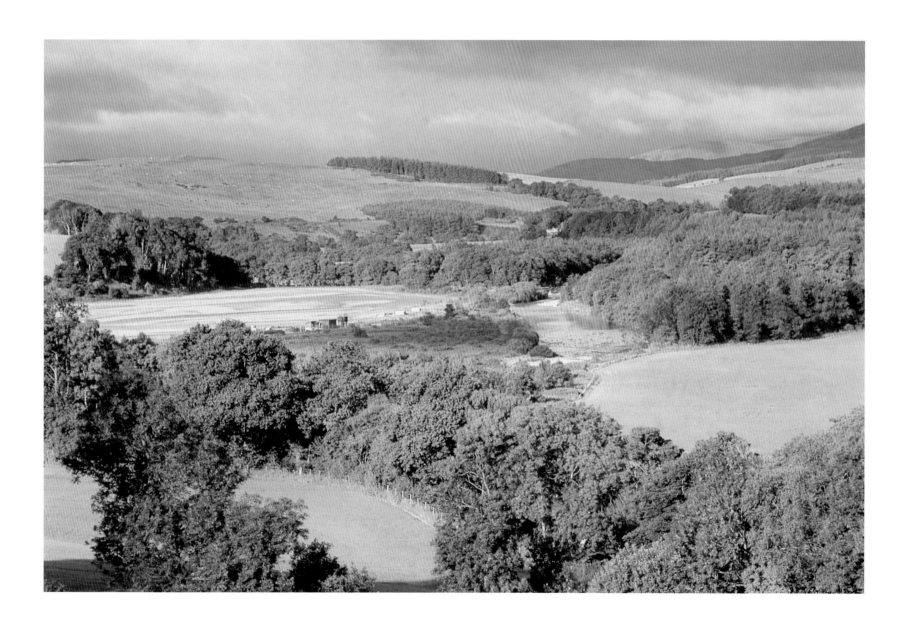

The Falls of Bruar, Blair Atholl, Perthshire

The favourite place of Ronnie Browne

For more than forty years, I travelled the roads of Scotland to perform the songs of Scotland in hotel lounges, farm barns, village halls and city concert halls. I couldn't possibly count the number of times I passed the sign on the A9 which pointed to the Falls of Bruar. Of course I was always in too much of a hurry driving between venues to stop. I don't even remember taking the time to read that this had been a famous beauty spot since Victorian times.

I found out just what I had been missing when, in 1981, on a short family holiday near Killiecrankie, I took the opportunity to visit the Falls for the first time to discover for myself just why so many people had been coming to the area for so long.

To say that they are breathtaking is an understatement. I don't mean it in the sense of Niagara or Victoria but just in the number of sights and sounds of water-carved grottoes and tunnels and pools encountered at every turn of the winding path up the gorge.

I particularly like the way Andy has caught the creamy, moving effect of the falling water to contrast with the rock-solid static bridge. The picture is, for me, the perfect reminder of the place and I hope that if, like me, you have passed by and not stopped, you will remedy that by not delaying any longer.

Stop, and take a hike.

Ronnie Browne

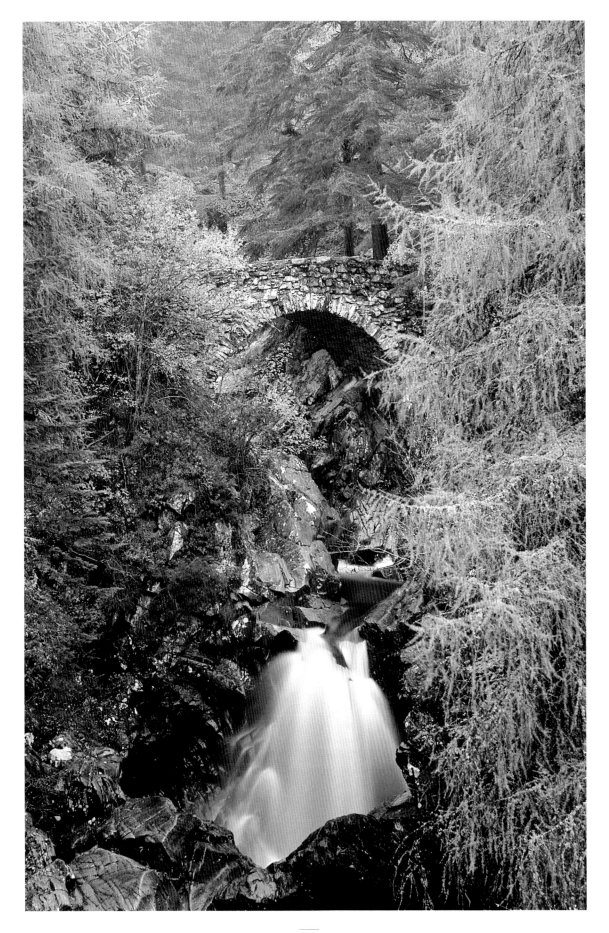

The Forth Rail Bridge
The favourite place of Iain Banks

The Forth Bridge must have had an effect on me. I grew up with it outside my bedroom window and I moved back to the same village a few years ago, so I still see it every day.

All mile and a quarter of it is floodlit now, so it even looks enormously impressive at night too. I love its distant grace, its close-up massiveness, the colour of its hollow red bones against the stark clarity of a blue summer sky and its veiled bulk sieving the mists and clouds swirling above the winter river.

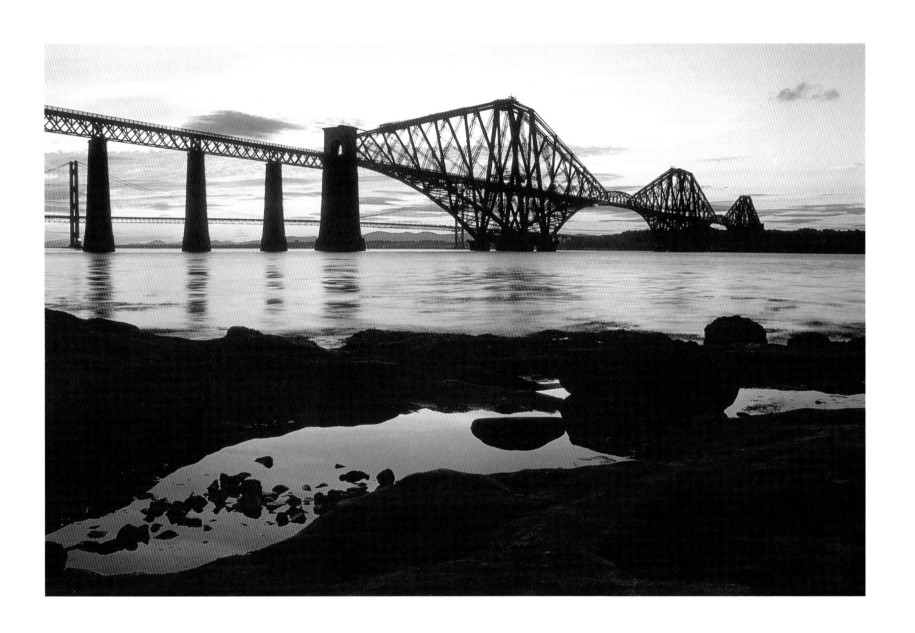

The Garden of Buchan, Old Deer, Aberdeenshire

The favourite place of Jack Webster

For the finale of the BBC drama-documentary about my childhood, *As Time Goes By*, I wandered alone among the ruins of the historic Abbey of Deer, three miles from the Aberdeenshire village of Maud, where I grew up.

As the final sweep of music I chose Elgar's deeply moving *Nimrod* and could feel history washing over me. For this haven of peace had stood since 1219, replacing an earlier monastery founded in the sixth century by St Columba and St Drostan, who brought Christianity to these parts.

It is an oasis amid the naked beauty of Buchan, the silence broken by the babble of the River Ugie as it wends towards the sea at Peterhead. These monasteries were the local inns of the day, offering the traveller a safe place from the highway robber.

In my childhood of the 1930s, the Roman Catholic priesthood came on a regular pilgrimage to this place, disgorged from the Buchan train which stopped at the little wooden platform just once a year. To the child it was a fearsome excitement. For the purpose of my 1987 television film, they re-enacted the procession, strange and haunting.

In glinting stone and sombre tree, Andy Hall's picture captures the mood within this spiritual home of Buchan, where I still come from time to time in search of peace and harmony.

Jack Webster

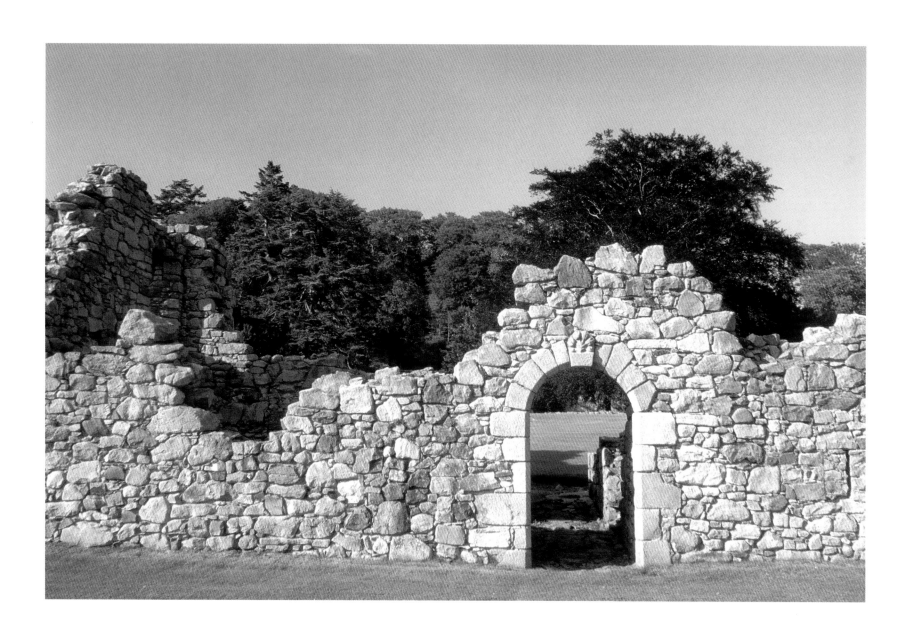

Glencoe, Argyllshire

The favourite place of Ally McCoist

Glencoe is my favourite place, because, as you can see from the picture, time has no relevance.

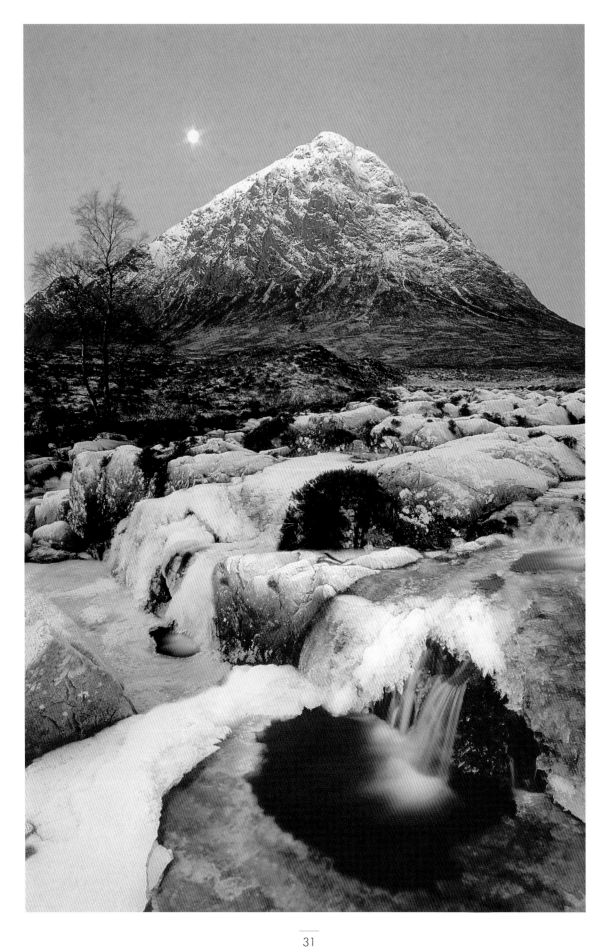

The Gleneagles Hotel Golf Courses, Perthshire

The favourite place of Stephen Hendry

Gleneagles is only a stone's throw from my home and during my leisure time I spend many a happy hour on the golf courses. Despite my world travels, Gleneagles still remains for me one of the most beautiful places on earth.

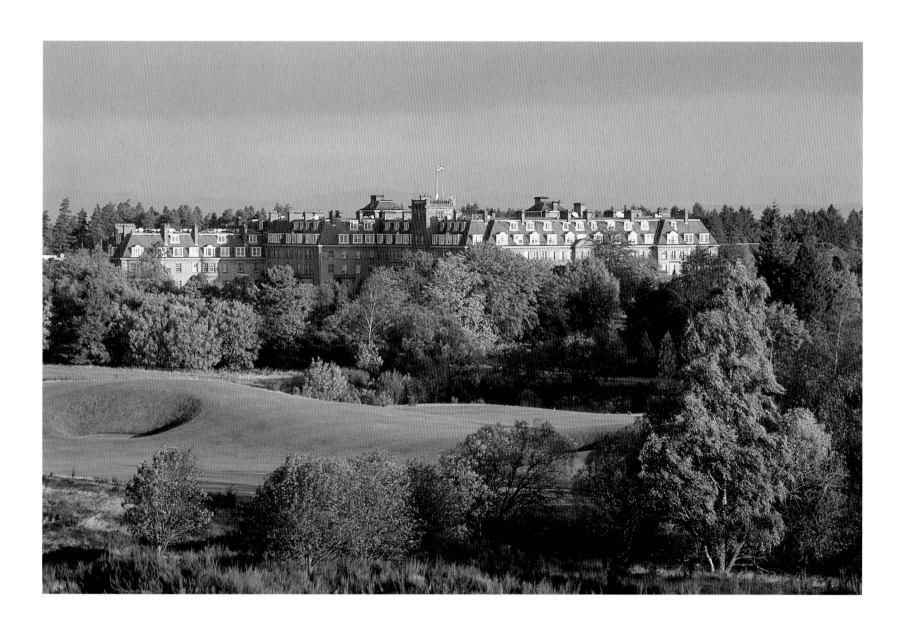

The Gogo Burn, Largs, Ayrshire

The favourite place of Daniela Nardini

The Gogo Burn runs through the grounds of my family home in Largs. To me it is the most special and peaceful place in the world. It's home!

Whenever I return, I wander through the woods to the old footbridge, stand in the centre, look eastwards in the mornings and westwards in the evenings, each creating a totally different effect, but sharing the calming and relaxing sound of the burn just under my feet.

Daniela Nardini

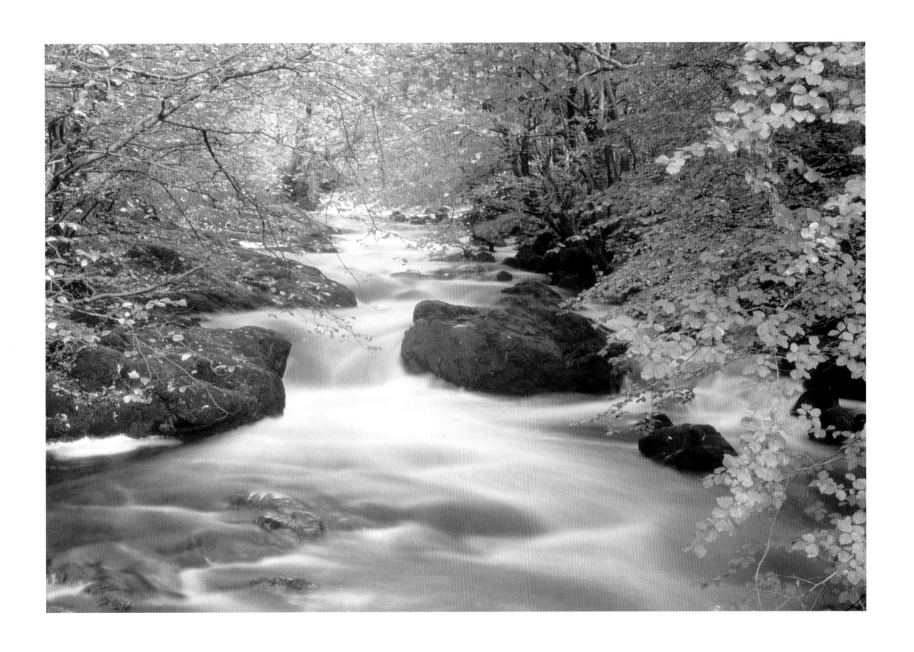

Govan, Glasgow

The favourite place of Sir Alex Ferguson

Looking at the photograph of the shipyard cranes invading the skyline evokes wonderful memories. Look how serene the picture is, and then think back and you realise that the very heartbeat of the Clyde is missing—the ships.

I can't believe what time has done to that great environment of noise, bustle and friendship. The caulker's hammer, the welder's flash, where has it all gone? And where is the Govan Ferry, where I was able to catch that incredible atmosphere of the shipbuilding era?

This picture represents the ghost of the Clyde, and yet a wonderful image of its past. When I look at it I can't help but feel the sadness and also the pride of being one of its sons. Long live the memory!

Alex Ferguson

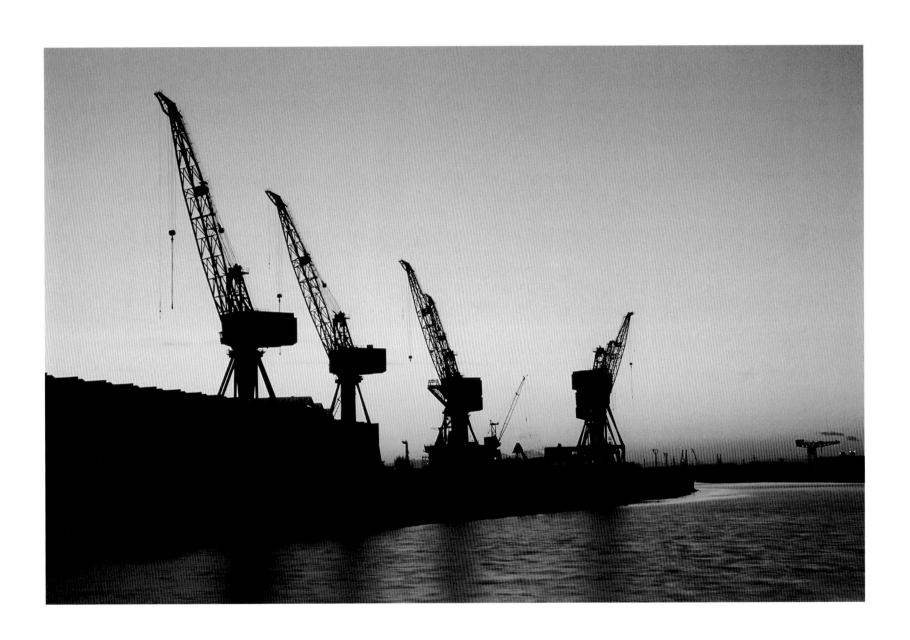

Grangemouth Refinery at Night, Stirlingshire

The favourite place of Kaye Adams

I know it must seem like a peculiar choice to many people, but Grangemouth is not exactly overwhelmed with memorable architecture and the refinery gives it an unforgettable landmark.

When I was very young, I found it quite a scary place which I'd be nervous of approaching on foot or on my bike. When I was driven through it, however, it seemed strangely glamorous.

I have to say this photograph perfectly captures my favourite view of the refinery. It has a magical quality at night, particularly near Christmas time. I always used to think it was the finest display of fairy lights in the land.

Having said all that, we should be grateful you can't smell a photograph!

Kaye Adams

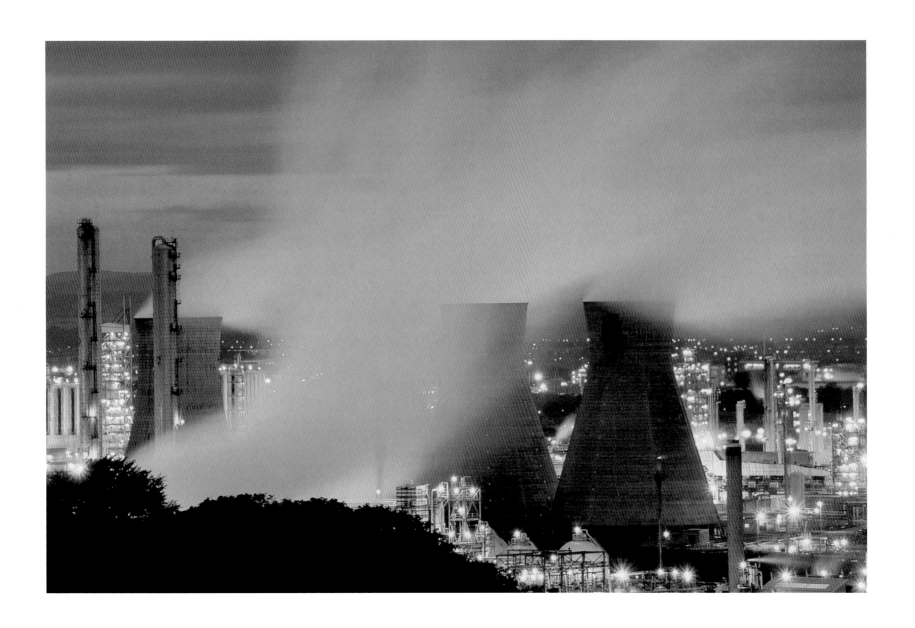

Haley Brae, Largs, Ayrshire
The favourite place of Billy McNeill

My first memory of the view over the Cumbraes from Haley Brae was as a young player with Celtic, travelling to Seamill Hydro for the first time. The spectacular vista of the island of Great Cumbrae and the Firth of Clyde caught my attention and has stayed with me ever since.

Often I stop the car when I reach the Brae and spend a few moments peacefully taking in what I consider to be one of the most wonderful sights I have encountered in my travels over the world.

The combination of the far Argyll shores, the multicoloured sea and the Cumbrae islands combine to make a picture that is typical of Scotland. I take great pride in being Scottish and I feel that this view from Haley Brae truly represents the beauty of our land and is a must for visitors from all over the globe.

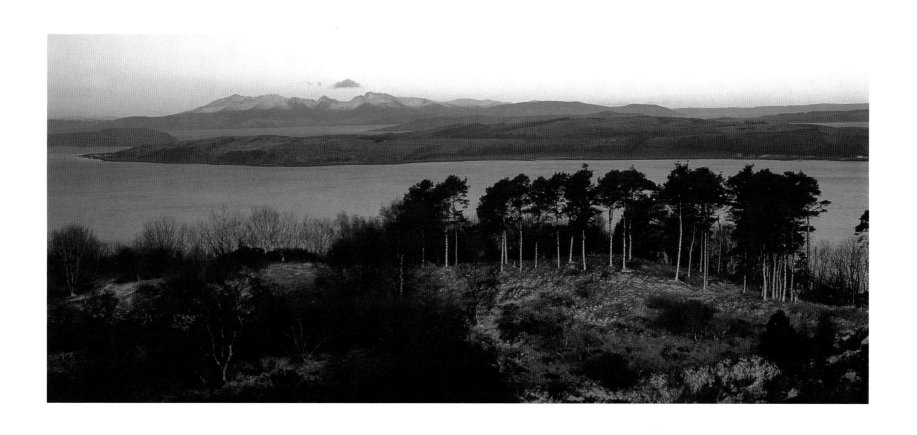

House for an Art Lover, Bellahouston Park, Glasgow

The favourite place of Carol Smillie

Living very close to Bellahouston Park, I watched with interest as this Charles Rennie Mackintosh-designed house was built a few years ago.

Everything about it appeals to me, the windows, the setting, the walled garden and the delicious food in the café, but my favourite part is the Music Room with its full-length screenprints and embroideries on the French windows, the piano and the sheer light, bright, airy feeling.

I'm there most weeks of the year for photo shoots, interviews, concerts or just having lunch.

It says everything about Glasgow's style and it is my special place.

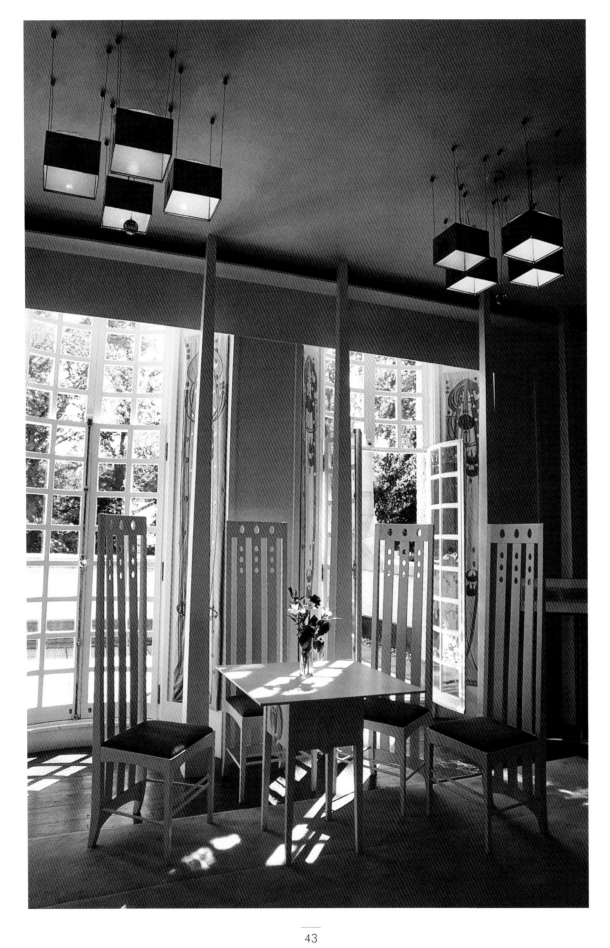

Hoy and Gutter Sound, Orkney

The favourite place of Sir Ludovic Kennedy

Although I have the happiest memories of my childhood in Edinburgh and summer holidays on the seafront at Nairn and in Islay, the photograph I have chosen is that of the east side of the Island of Hoy which lies on the west side of Scapa Flow in the Orkney Islands.

In the centre of the frame lies the habitation of Lyness which fronts on to Gutter Sound, two places that still have a very special place in my heart. During the last war, Gutter Sound was the anchorage of the destroyer flotillas of the Home Fleet, among them HMS *Tartar* in which I served from 1940-42. It was the harbour from which we set out to take part in the Norwegian campaign, to escort the Arctic convoys to Russia, to chase the *Bismarck* and to hunt for the *Tirpitz*: and the place where, on return from perhaps two weeks at sea, mail from family and friends awaited us. It was our only link with home, and I recall we couldn't open the letters fast enough.

Not that there was much to do after we had anchored. Admiral Beatty, who was at Scapa in the first war, called it the most damnable place on earth and most of the navy agreed. Hoy was almost treeless, just heather and grass, seabirds and sheep, and across Gutter Sound the wind fiercely blew, often for days on end. At Lyness there were no women, shops, restaurants, just a couple of canteens that dispensed warm beer, a hall for film shows and the occasional concert party, and a brace of football fields that too often fathered the signal, All Grounds Unfit For Play.

But on board the ship, we fed well, and drink and tobacco were duty free (cigarettes a shilling for twenty, gin two pence a glass). Sometimes in the evenings, we would entertain or be entertained in the flotilla's wardrooms and dress up as Tartars, Eskimos, Bedouins; or there were evenings of film shows, which were often improved by the last reel appearing first and upside down. And we sang songs too:

> *Oh, we had to carry Carrie to the ferry,*
> *And the ferry carried Carrie to the shore,*
> *And the reason that we had to carry Carrie was*
> *Poor Carrie couldn't carry any more.*

There were other compensations, especially in summer when the hills of Hoy were touched with purples and greens and the Flow sparkled blue in the morning sun; at night too when the Northern Lights wove pale patterns in the sky the place had a rare beauty. There were afternoons when some of us would walk the two miles to Longhope to buy fresh eggs or lobsters. Or I might take my fishing rod ashore, climb a hill above the anchorage, on the other side of which lay an attractive trout loch, and there spend a couple of contented hours away from all navy sights and sounds, though every half hour or so, I had to mount the hill to make sure that the *Tartar* was not flying the Blue Peter, the signal for recall.

I have been back to Scapa several times since, once to make a documentary film on the place which included an interview with the engineer officer of the U-boat which in 1939 had penetrated the Flow and sunk the battleship *Royal Oak* with huge loss of life. On every occasion, though, I find it's the happy things I remember about my life there sixty years ago, especially the camaraderie of fellow officers, and despite the wartime drawbacks, I still find the place retains a magic all its own.

Ludovic Kennedy

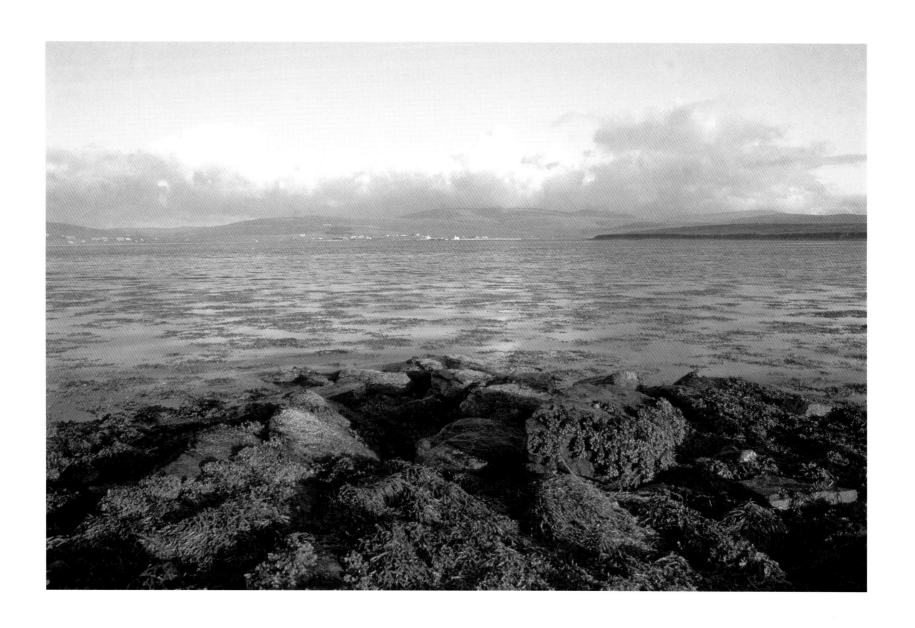

Invergowrie Bay, Dundee
The favourite place of Michael Marra

This view of Newburgh from the other side of the majestic River Tay takes me back to my childhood when my mother took my brothers, my sister and myself to Invergowrie Bay. I was reading *Tom Sawyer* at the time, which had a great effect on me, and in the early evening the Newburgh lights transformed the village into a Mississippi River Boat. This was probably reinforced by the fact that one of the 'Fifies' featured big paddles, seriously moustachioed men and girls in their finery of the '50s.

This view is from Kingoodie, next to the flooded quarry. They said it was bottomless, *and* that there was a house at the bottom. It's a very dreamy place with beautiful smells and I returned many times. It was a great place to go with a girl, as I was able to point out the Pyramids and over past Wormit, the edge of China. It gave me the chance to seem both knowledgeable and sensitive.

The photographer obviously has a feeling for the Blues.

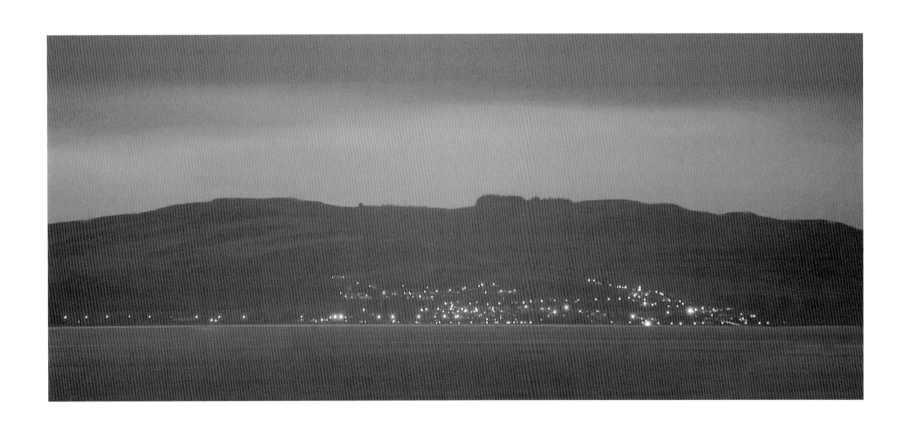

Kelvingrove Art Gallery & Museum, Glasgow

The favourite place of Eddi Reader

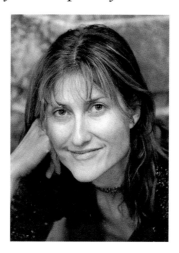

When I fancied myself as a famous but troubled artist during my teens, I would spend every weekend up at the Kelvin Galleries sketching the 'Fishermen's Wives', gazing for hours at 'The Crucifixion' by Dali… or desperately looking for clues in the exhibitions of ancient ballroom gowns fully displayed with their gloves and little dance books.

I would be totally lost in the pencilled-in names on the books (obviously a queuing system for the blokes to dance with whoever was wearing the gown), which provided many hours of fantasy for me. It opened up all my creativity being exposed to all that. Thank you, Kelvin Galleries.

Eddi Reader x

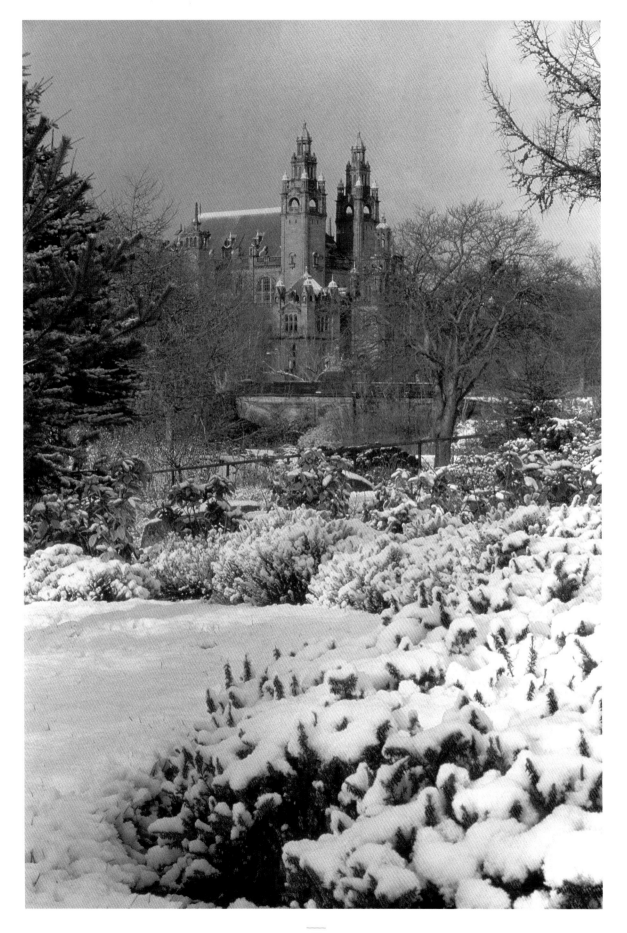

King's College Quadrangle, Old Aberdeen
The favourite place of Buff Hardie

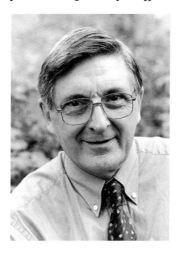

I spent four years in the 1950s as a student at King's College, Old Aberdeen, which was a wonderful setting for one's salad days. From almost every angle it is marvellously photogenic and in selecting a photograph it is perhaps a little perverse of me to ask for nothing more spectacular than the old well which is a feature of the College quadrangle.

Its most avid admirer could never claim that the well contributed a lot to the education of the mid twentieth-century undergraduate. You could lean against it; you could perch on it and chat; and you could look down into it. It was, and is, a solid stone structure, sunk to a considerable depth, and it has an attraction, as low-lying water tends to have, for low-denomination coins of the realm, tossed down from above. Over a period these coins—and their value—could mount up, and I can recall one desperate student who, having worked his way through his entire grant in the Union bar long before the end of term, got himself lowered down the well and collected a sizeable sum in small coins with which to finance his next pint.

Many years later I took part in a BBC Television programme called *The Antiques Inspectors*. Presented by Carol Vorderman, it was a variation on *The Antiques Roadshow* and it involved a team of antiques experts visiting a town or city and assessing antiques that were brought before them in private houses and other locations. One of the cities they visited was Aberdeen, where my role was that of native Aberdonian who acted as a guide to the team as they made their way about the city.

At one point they visited King's College and its fifteenth-century chapel. I had to show Carol Vorderman round the policies, and in doing so I took her to the well. We looked down into it, and the cameraman succeeded in getting a shot which revealed that the practice of tossing coins into the well still continues. That being so, I told the story of the impecunious student who had descended into the well in pursuit of his beer money. As I ended the story, I said on impulse, 'That chap is now a Judge in the Court of Session.' It wasn't true, but I plead poetic licence. It was surely a permissible fiction, and it seemed like a nice way to end the story. The programme director thought so too, and the fictitious ending survived the editing of the tape. In other words, he kept it in.

The programme was transmitted a few weeks later, and the following day I received a card through the post. All it said was, 'I did <u>not</u> remove the money from the King's College well.' It was signed by the only Court of Session judge who is a graduate of Aberdeen University.

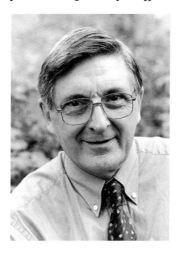

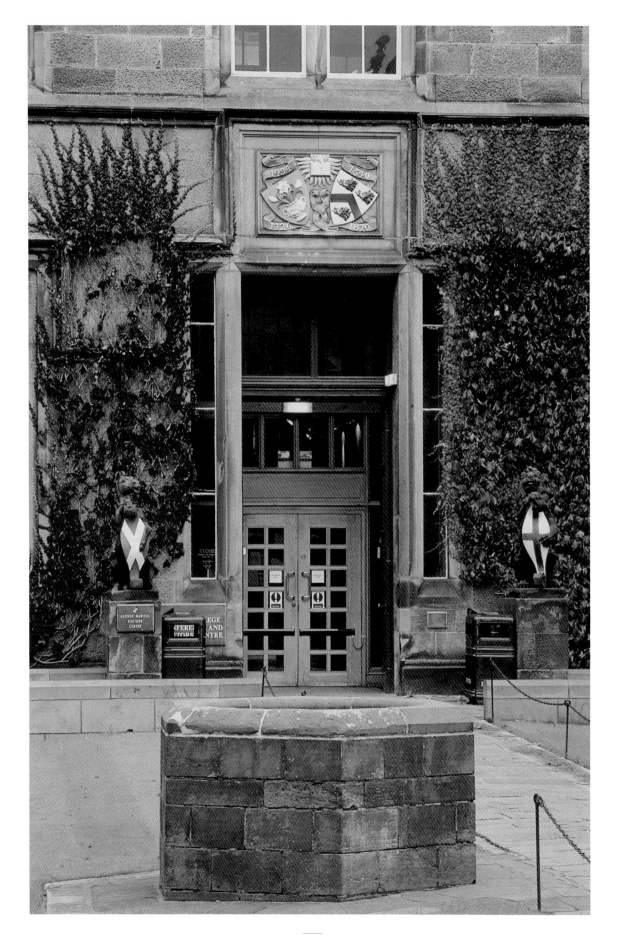

Kinnoull Hill, Perth

The favourite place of Brian Cox

I remember it was just before my eighth birthday and the beginning of the summer, my birthday being the first of June, and my sister had just been taken to Dundee Royal Infirmary to give birth to my nephew, David. I remember my dad, my mum and my brother-in-law Dave going to Kinnoull, climbing up past the Cistercian Monastery up to the Folly. It had intrigued me ever since I was a baby when I used to go to Glasgow by car and see this lonely keep standing sentinel over the Tay Valley. Of course I didn't know then that this was a folly and had been designed as a homage to the Rhine, I forget by whom now, but some Scottish laird.

I can still physically feel it so strongly that when my dad and I came up to Kinnoull, there was a very narrow ledge across to the Folly, which I was a little fearful of. My dad slung me on his back and, closing my eyes, he took me across the ledge to the Folly. There we sat, eating sandwich spread sandwiches with bits of cheddar cheese, and gazing at the Tay Valley. I remember that my father was wearing a sleeveless, fawn-coloured pullover, and I had these tweed shorts on which used to chafe my inner thighs. My dad was so transfixed by the view that we just sat there in wonderment. We were alone so I don't know what happened to the rest of the party. I remember a great sense of literally being above it all and my dad said to me: 'You'll never see a finer view in your life, Brian.' I think this was the last private moment my father and I ever spent together, because within a year he was dead. The feeling was one of festivity, because here he was with his youngest son and proud of the fact that a grandson had just been born to him.

Kinnoull is about texture, smell and intimacy. Whenever I see Kinnoull Hill from the Perth Road, it is 100% associated with my dad and I always feel that his spirit is there watching, waiting for me to come home. This photograph completely captures everything I feel about Kinnoull.

Andy, a million thanks. I am so thrilled with it.

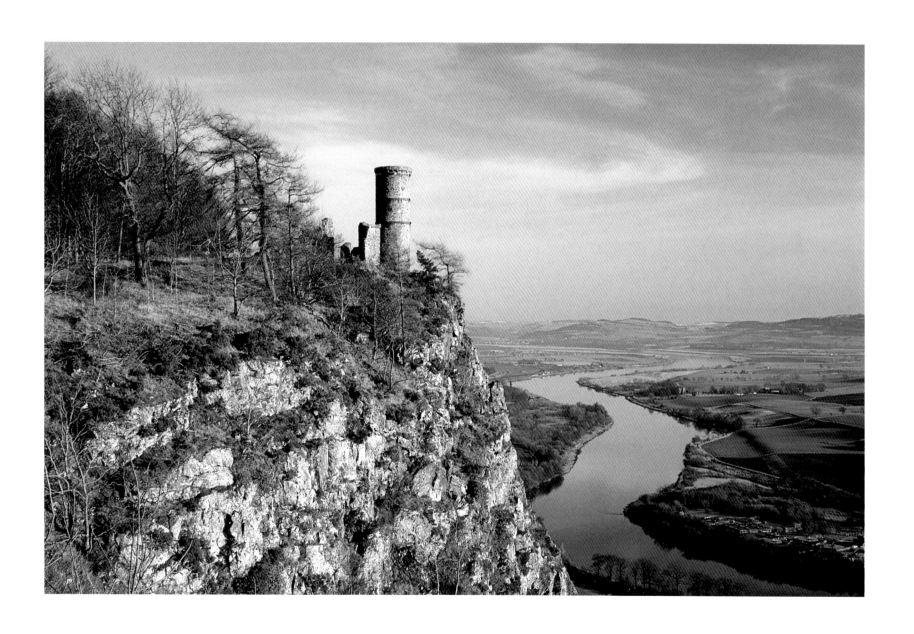

The Knock, Crieff, Perthshire

The favourite place of Ewan McGregor

The Knock in Crieff is a very special place to me. It reminds me of childhood holidays, of freedom and getting up to no good! I especially like this view looking over to Comrie from the indicator.

This particular picture has an almost three-dimensional effect. I really like the shiny film stock used. Many thanks for taking it and giving me a permanent, visual reminder of home.

The photographs in this book will inspire the beautiful melancholia experienced by Scots away from home all over the world.

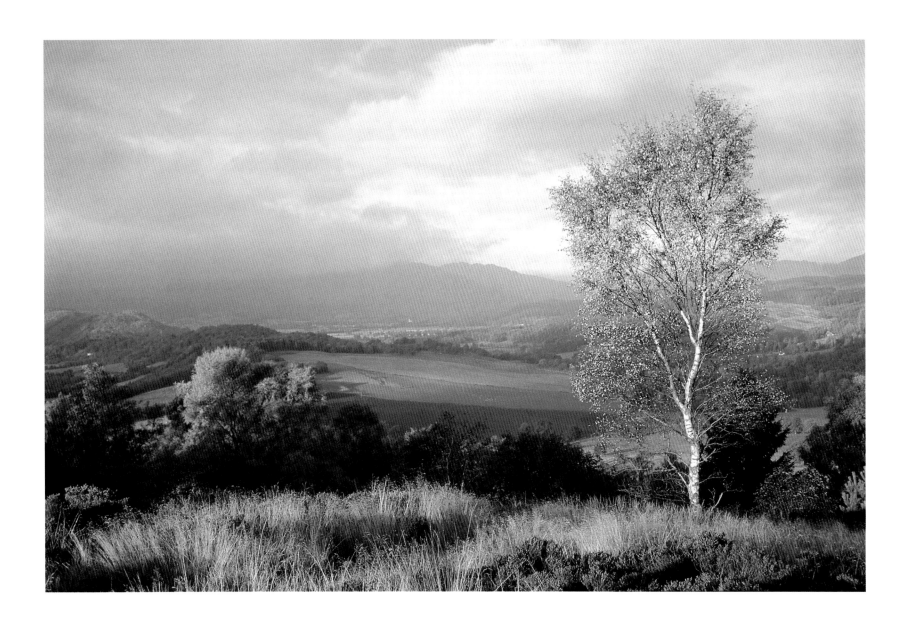

Lady Mary's Walk, Crieff, Perthshire

The favourite place of Denis Lawson

This is pretty well a perfect shot of Lady Mary's Walk for me; taken at just the right time of year, the autumn. The colours and the light are just as I carry them in my head when I'm away.

This spot has strong personal associations for my family and myself. Since the age of three, I've loved this walk along the banks of the River Earn which I swam in throughout my childhood (only in the summers of course!). Indeed as recently as last year I had an invigorating dip.

For the first few years that I lived in London I was compelled to return to see this view as it changed through each season. It's a constantly changing canvas, no matter how often you visit it.

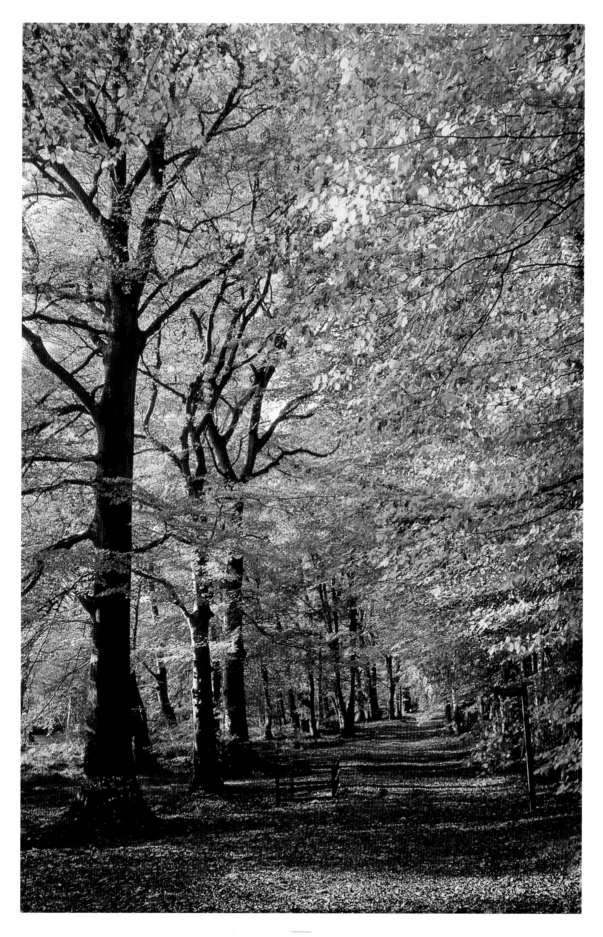

The Lake of Menteith, Stirlingshire

The favourite place of Nick Nairn

I grew up with this view, looking across the Lake of Menteith to Ben Lomond, and am lucky enough to enjoy it nearly every day of my life. It's never the same two days in a row. For instance today, as I write, the water is steely grey and Ben Lomond is invisible behind a curtain of mist, whereas Andy's picture is chocolate-box perfect. He took this picture in the summer, when we get the most spectacular sunsets—sometimes you can almost imagine Ben Lomond as an active volcano spewing lava across the horizon.

Having known this view all my life, it never fails to stimulate or soothe me. Somehow, and I can't explain this rationally, it helps define my Scottishness, it connects me to the landscape—especially the play between hills, water and light which, for me, are the essence of Scotland.

Nick Nairn

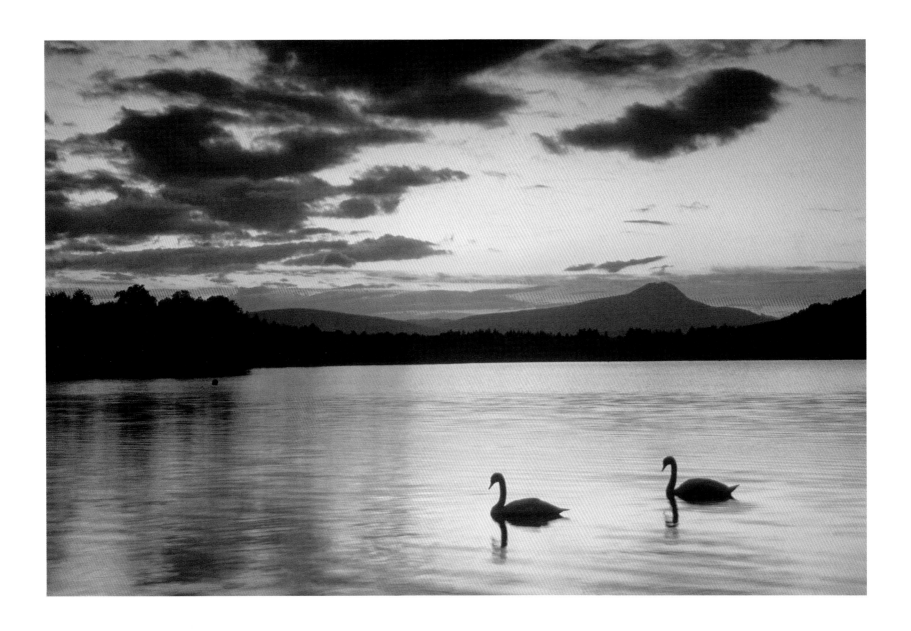

Lamlash Golf Course, Isle of Arran

The favourite place of Craig Brown

As a teenager in the late '50s, I spent many hours while on holiday playing golf on the attractive, hilly Lamlash Golf Course. Vivid in my memory are the sights from the vantage points on the course, particularly the first green and second tee.

Having travelled extensively throughout the world, I feel I am in a position to make value judgements on the scenery here in Scotland. When I say that one of the most delightful views is from Lamlash Golf Course across the bay and Holy Isle towards the Ayrshire Coast, I feel I am speaking with authority.

The photograph, because of the monochromatic light, and with a ship in the bay is, in my opinion, quite exquisite and a compliment to the consummate skill of Andy Hall. I am most indebted to Andy for providing me with such a poignant reminder of my youth on the tranquil island of Arran.

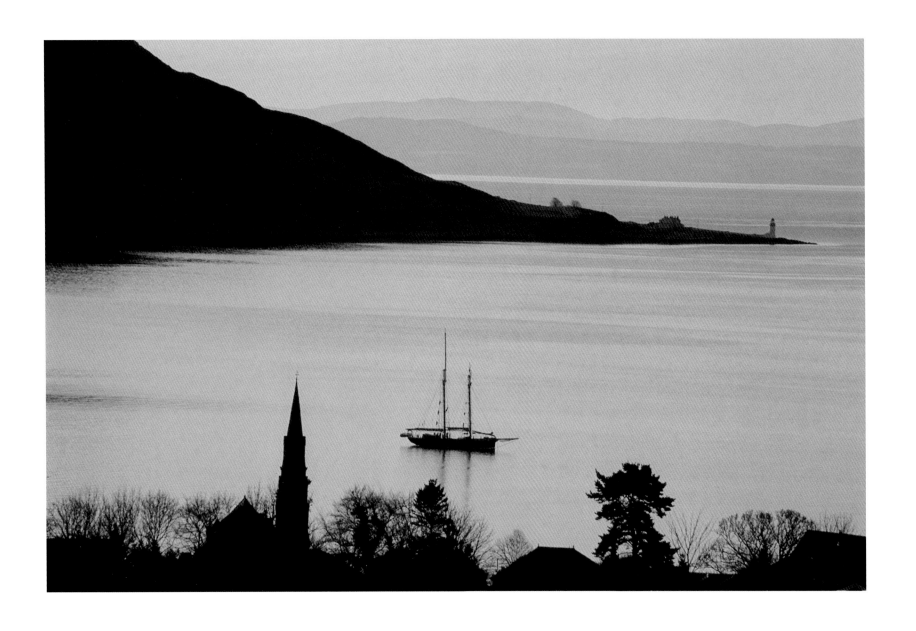

Langholm, Dumfriesshire
The favourite place of Gregor Fisher

Langholm—a place that made a huge impact on an adolescent boy and taught him the value of friendship and humour! A place that not only stirs the heart with its beauty but welcomes you back after years away from her, as though you had been gone for only a moment.

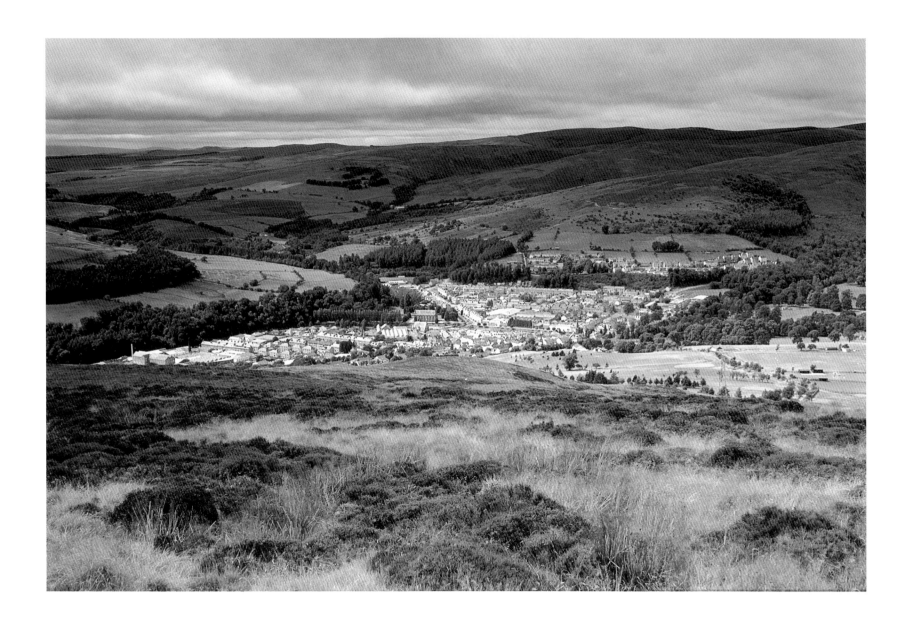

Loch Lomond Golf Club, 17th Green

The favourite place of Gordon Smith

I was thrilled to play Loch Lomond because of its reputation for being one of the world's most challenging courses set in one of Scotland's most beautiful locations. The walk was spectacular even if, at times, the golf was not.

However, I well remember the moment on the 17th green as I crouched to get a line on what was still a crucial putt. In an instant I had looked over beyond my ball and had taken in a view that was of stunning beauty and tranquillity. I was moved to stand up and invite my playing partners to enjoy the scene with me, which they duly did.

I don't believe that a moment like that can be captured in a still photograph but I have to compliment Andy on his beautiful shot which goes a long way to replicating my exact view of the Loch and surrounding hills. It's a marvellous photograph which encapsulates my 'moment' and evokes pleasant memories of a special day.

Gordon Smith

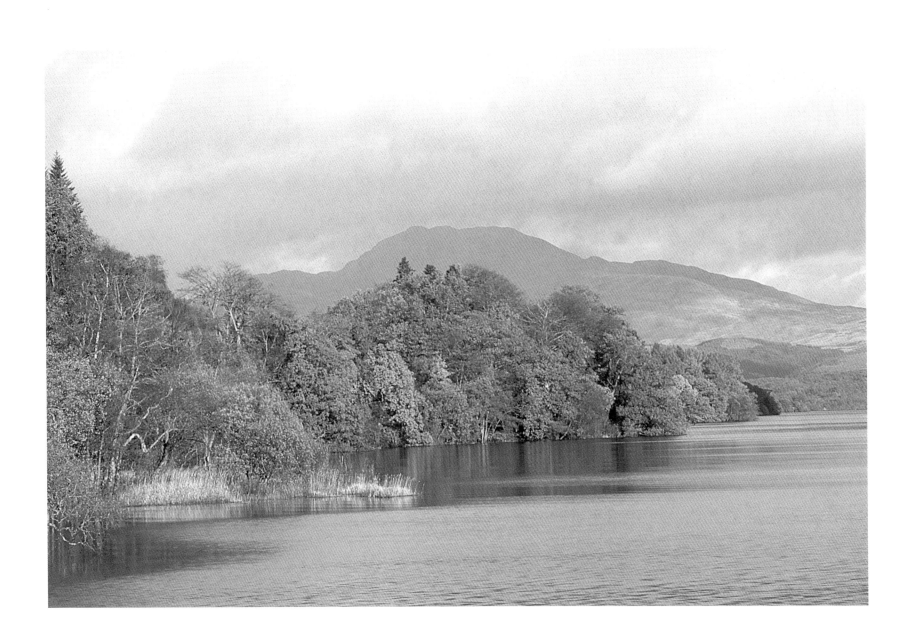

Loch Morar, Lochaber

The favourite place of Sir Cameron Mackintosh

I first went to the West Coast with my grandmother and aunts in the early 1950s when I was six. The idea of sleeping on a steam train had me wild with excitement from the moment I boarded the West Highland overnight express at London's King's Cross Station—a marvellously grimy and mysterious cathedral of a building, filled with the hubbub of bustling crowds and swirling steam. It was a great adventure to wake up in the early morning and be given a delicious bacon sandwich at Crianlarich Station, after which the train laboured over the stark, rugged beauty of Rannoch Moor, the line's highest point at over 1,000 feet. The rail journey then continued down to Fort William and along the 'Road to the Isles' to Mallaig. It is one of the most beautiful in the world and it has never failed to thrill me. Before one arrives in Mallaig, you pass the shimmering silvery sands of Morar, still mainly unspoiled and featuring spectacular views out to the Isles of Rum, Eigg and Skye. Here, with my bucket and spade, I dug sandcastles, collected shells, found a myriad of creatures under rocks and seaweed and beautiful driftwood shaped by the wind and stormy Atlantic seas. I thought it was paradise and though I now have had the luck to travel the world, it still remains virtually unchanged and is the most special place I have ever visited.

Over the years, I've got to know some of the mysteries that sandwich themselves between the hustle and bustle of the busy seaport of Mallaig. I've languished among the beautiful, almost tropical, islands that lie in Loch Morar, covered with fully-grown and untouched forest, left just as nature intended. Whatever the weather, the whole area has an extraordinary beauty; even when it's really wet, it's nice to be indoors by a nice fire with a dram and watch the weather rush by.

When the sun is shining (and it does much more than people think), then its unspoiled beauty is incomparable. Long known as a fabulous area to sail in, there are numerous idyllic spots to explore around the coast and nearby islands. My estate is bounded to the south by Loch Morar, which is the deepest inland freshwater lake in Europe, and to the north by the sea loch, Loch Nevis (which is Gaelic for Heaven), and has fantastic views over the Cuillin Mountains in Skye.

The sunsets on the West Coast are quite magnificent and this beautiful photograph gives just a taste of the magic of the place. Recently I travelled to Patagonia and when I got there, enjoyable as it was, I felt that the West Coast of Scotland was a lot more spectacular and varied and much easier to get to!

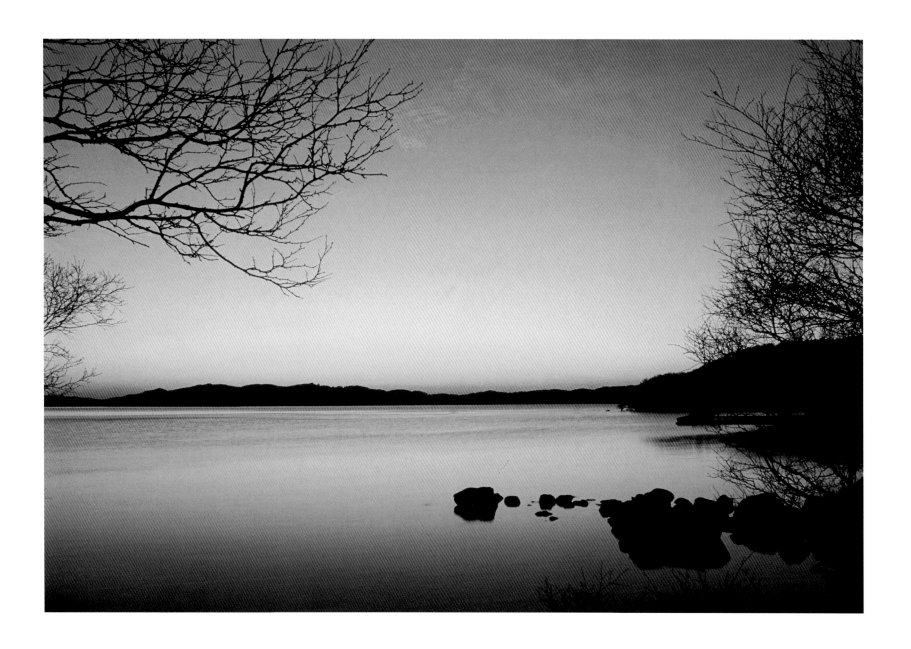

Lochgelly Loch, Fife

The favourite place of Jim Leishman

For me, Lochgelly Loch holds many fond memories from childhood and growing up. As a youngster, I spent many happy times camping beside the loch. Myself and several friends learned to swim in there and we would spend hours fishing for pike and perch during the school holidays.

As I grew up, I also learned to water-ski on the loch and, after several dunkings, I eventually managed to stay standing! The loch also has strong family connections as myself, my father, brother and sister would go for long walks in the area.

To me, Lochgelly Loch is a place of peace and tranquillity, where I can escape from the world of football for a while!

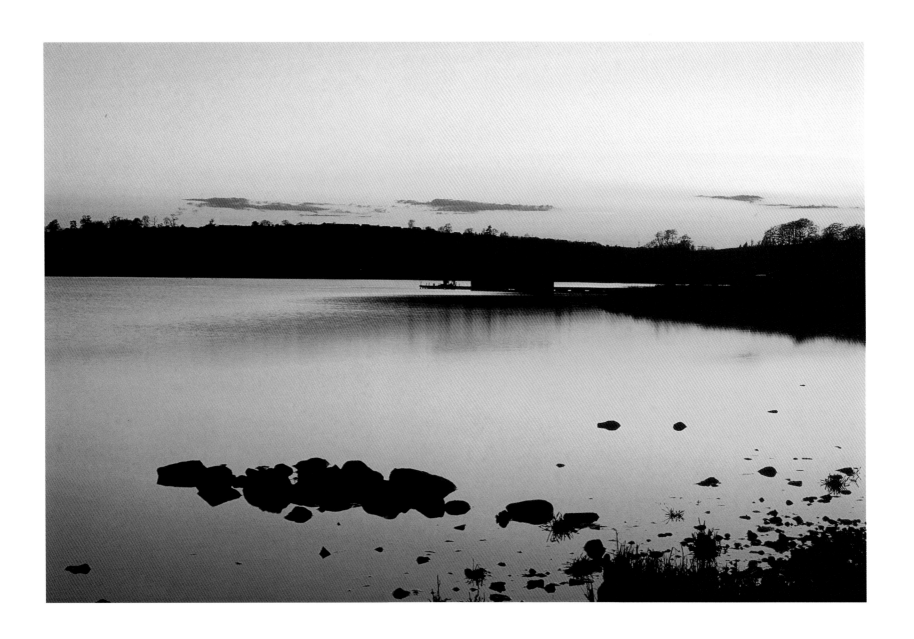

Millport, Great Cumbrae Island, Ayrshire
The favourite place of Bill Paterson

Is there anything more difficult than choosing one place in all of Scotland? So keep it simple and go back to childhood.

I spent every August for nearly twenty years in Millport on the Isle of Cumbrae and even in those busy weeks there was always something lonely and wild at this spot just round Portachur Point from the West Bay. The dark volcanic rocks, the reddish shingle and the wonderful view of Arran make it almost Hebridean, and it's only thirty miles by seagull from Sauchiehall Street! You could even see basking sharks here.

This photograph really captures those textures and that restless firth. I love that dusting of snow on Arran. Most Augusts we missed the snow!

Bill Paterson

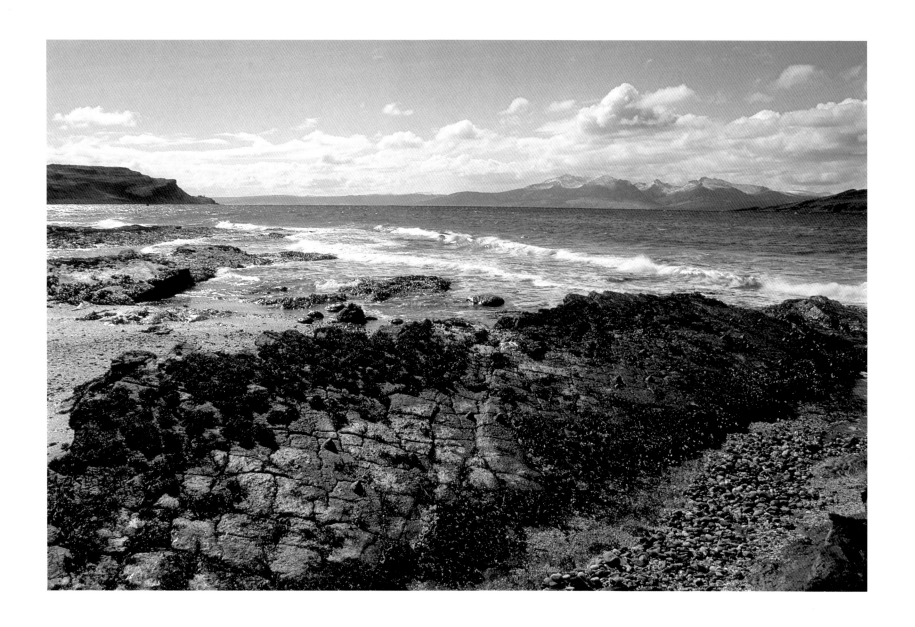

Morinsh, Ballindalloch, Speyside

The favourite place of Eileen McCallum

Morinsh in Ballindalloch holds a very special place in my heart. For many years our family had a cottage here and we opened our front door to Ben Rinnes every morning of the holidays, summer and winter. Andy has captured its majesty covered in snow against an incredible sky.

How grateful we should be for our country's wilder places, where time seems to stand still. The landscape of the North East has changed little since my childhood.

Eileen McCallum

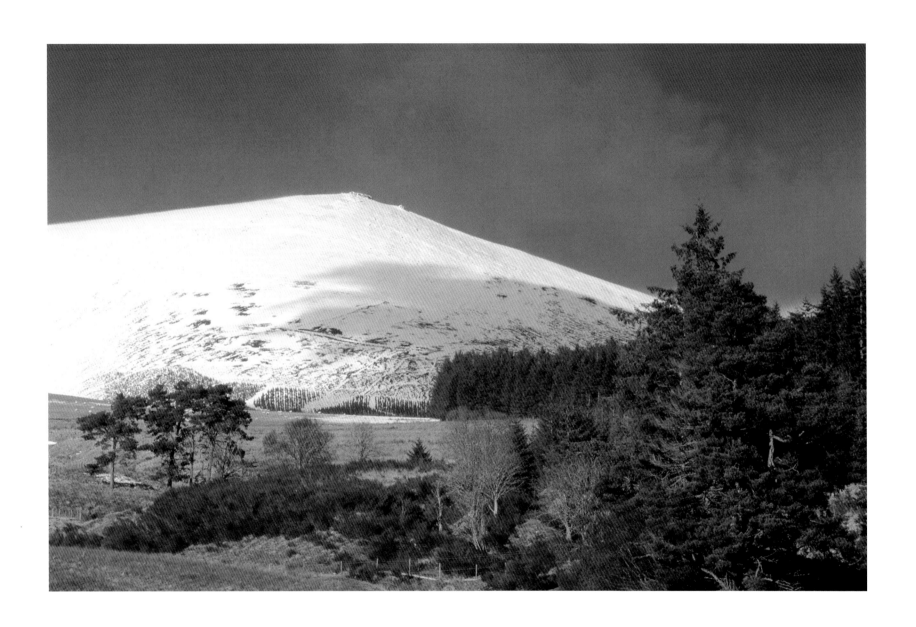

The Oxford Bar, Edinburgh

The favourite place of Ian Rankin

To me, the Oxford Bar is an oasis. When I see that old, battered sign, I know I'm near friends and kindred spirits. The sign represents an old, unchanging Edinburgh, a tradition of friendship and storytelling.

Also, to me, the Oxford Bar represents another aspect of the hidden city. It's a minute's walk from Princes Street, but is hard to find. It's a 'well-kent secret', like the city itself.

Ian Rankin

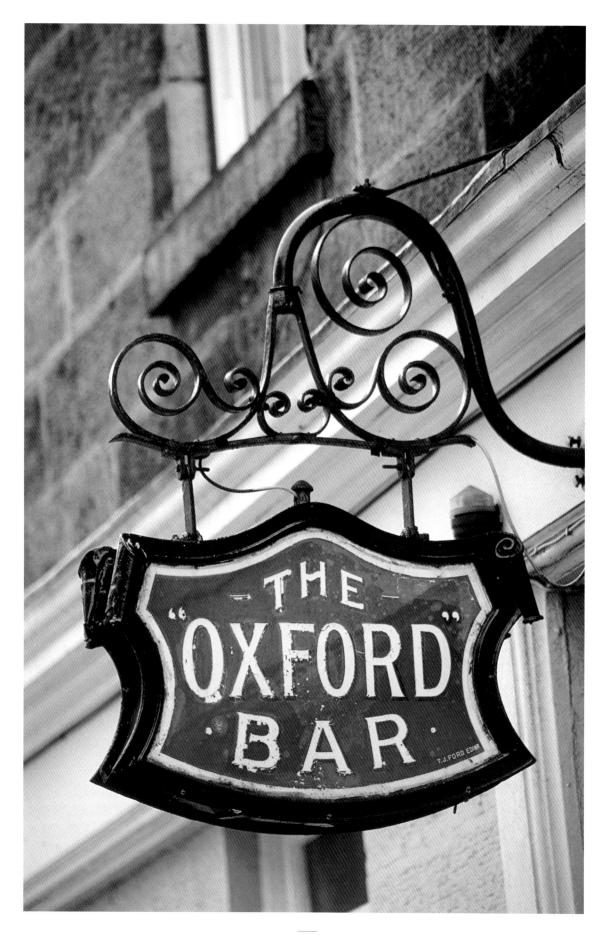

The Pencil, Largs, Ayrshire
The favourite place of Sam Torrance

They say that home is where the heart is. This is definitely where my heart is. I have been to many beautiful places around the world, but none please me more than this.

When I lived in Largs, this view from my bedroom window managed to have a different look every day. I could sit and look at it for hours on end. I hope you enjoy the view as much as I did.

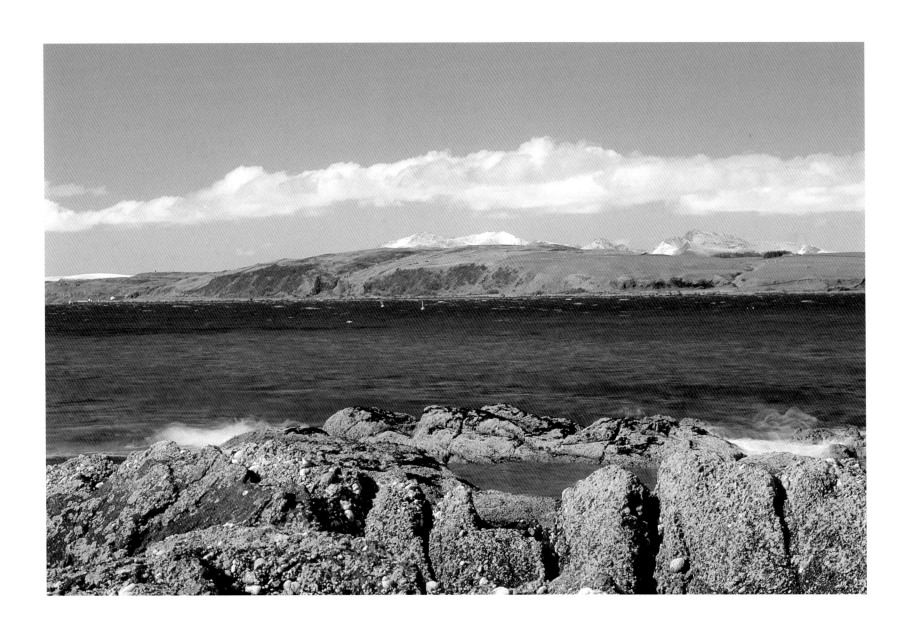

Plockton, Wester Ross

The favourite place of Jonathan Watson

My wife used to visit Plockton as a child and loved the place.
We travelled there a few weeks before our son, Jack, was born
and, since then, we have made it a regular family destination
during the summer months. It's a great place to relax.

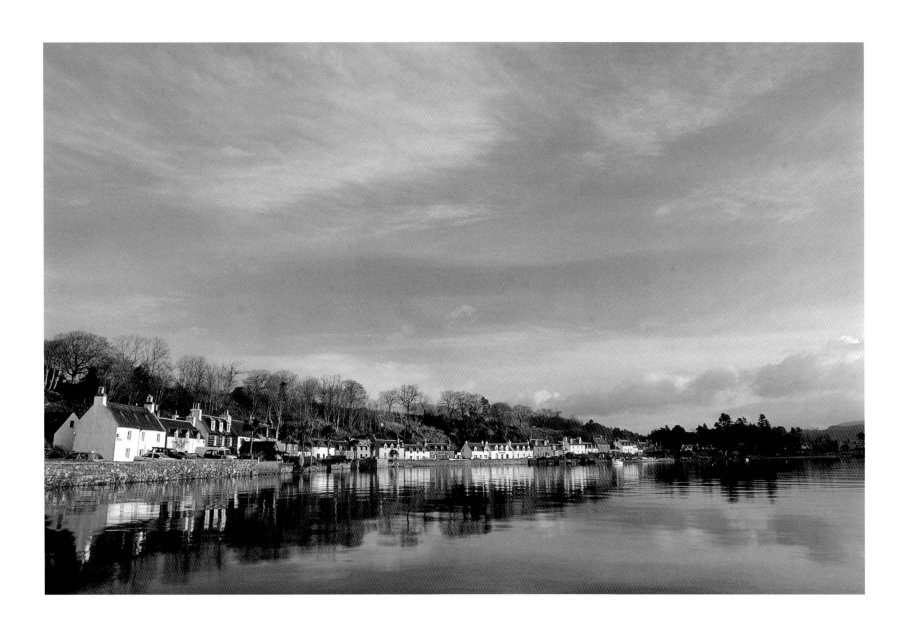

Port Appin, Argyllshire
The favourite place of Kirsty Young

The view from the mainland at Port Appin across Loch Linnhe and onto Lismore brings back golden memories of a weekend I spent there in September of 1998. The simplicity and strength of the landscape, broken only by a helpful wee lighthouse, is perfect.

When I'm home in Scotland, I treasure the humour and the fresh air and on that weekend I had plenty of both.

Kirsty Young

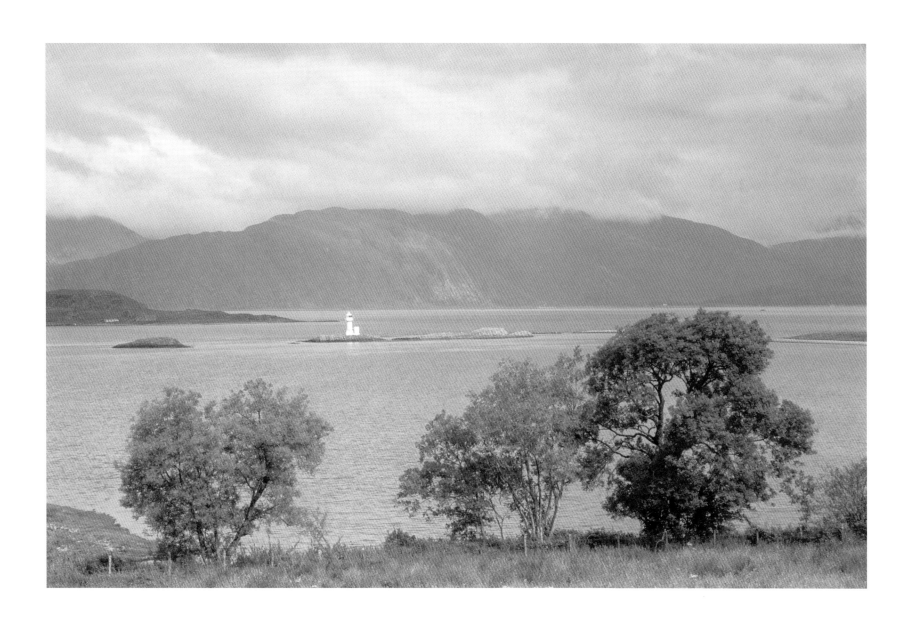

The River Ericht, Rattray, Perthshire

The favourite place of Fred MacAulay

I was privileged to grow up in Perthshire: Callander, Killin, Rattray and Scone. At both Killin and Rattray, the rivers Dochart and Ericht were significant in my surroundings and my upbringing. My parents still recall the time I pedalled my tricycle into the lade at the side of the Dochart when I was five years old.

But it is the Ericht that I remember more. It had claimed the life of one of the boys in my Cubs and maybe that gives it an extra air of mystery. I used to cross it on a daily basis and it was never the same twice. On the one hand, I've seen it so dry that you could have walked over the stones without getting your feet wet (not that I tried). And I've seen it in terrifying full spate after a period of sustained rainfall or in spring with the snows melting on the hills.

I don't know why, but my memory is of always crossing the bridge on the upstream side and staring at where all the water was coming from, just as you see in the photograph, rarely looking down to where the river flowed away. Maybe that says something about my character or my psyche. Or maybe it's because that's the side of the road our house was on!

Fred MacAulay

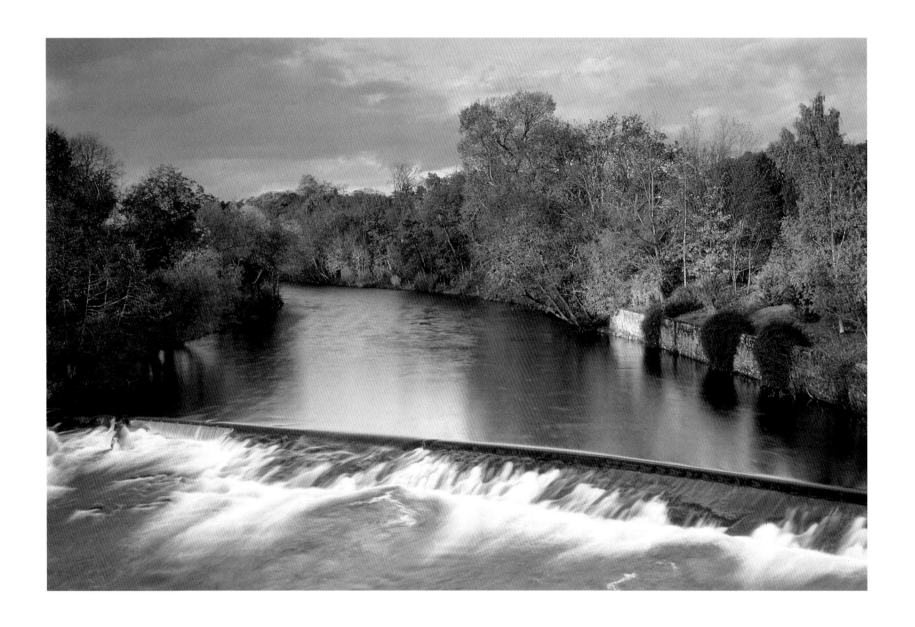

Sannox Glen, Isle of Arran

The favourite place of Richard Wilson

This view of Glen Sannox brings back many happy times there on family holidays. We stayed at a small hotel called Ingledene run by Peggy and Gilbert McKinnon. Every time the bus arrived Peggy would come down the drive wiping the flour from her hands—she was a wonderful cook and wonderful hotelier.

Glen Sannox was a beautiful place as the photograph so brilliantly shows. There was excellent walking in the hills behind the house and I particularly remember going out with Gilbert (a shepherd) and his dogs, a very exciting task for a young boy!

Richard Wilson

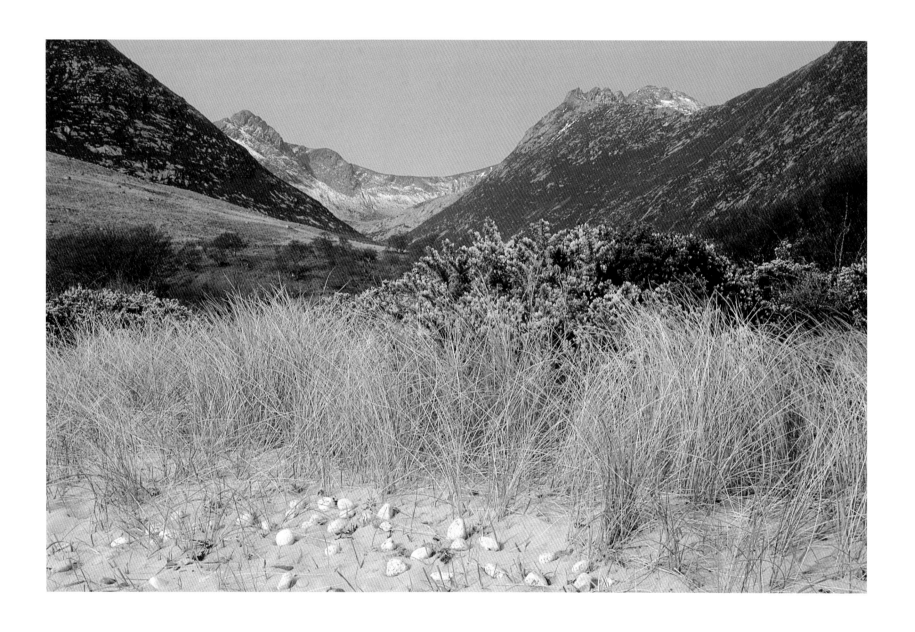

The Sleeping Warrior, Isle of Arran

The favourite place of Kirsty Wark

There's a point on the road from Lamlash to Brodick when you rise up the hill and get your first sight of the mountains and hills of Goatfell and the Sleeping Warrior. I look forward to that moment every time I make that journey. When the hills are snow-capped the view takes on another aspect—it could be the Himalayas!

This scene roots me to Scotland—I couldn't imagine not being able to see it. When it comes into view, I get a great sense of belonging.

Kirsty Wark

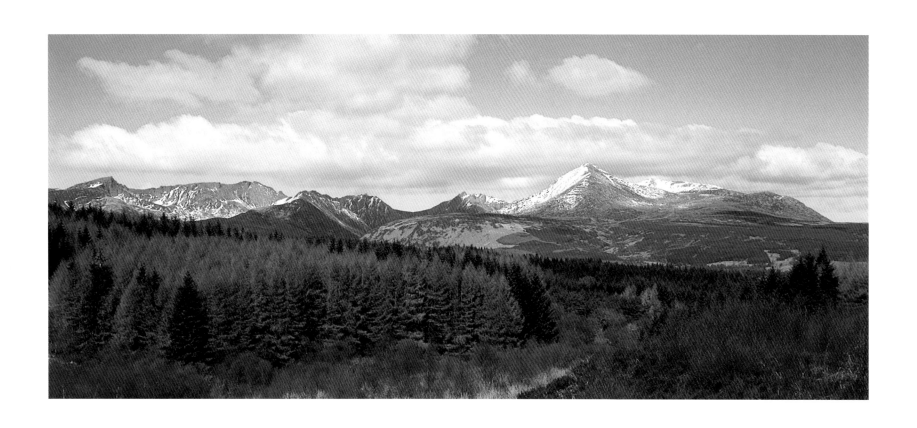

Stronachlachar, Loch Katrine, the Trossachs

The favourite place of Jimmie Macgregor

In the film *Rob Roy*, there is a dramatic scene in an old castle on a tangled island. The night is black and there are murky deeds afoot. A deadly confrontation takes place in which actor Brian Cox, who is very good at being a baddie, gets his comeuppance from an obvious goodie, a Macgregor. The baddie is one Graeme of Killearn, a nonentity raised to notoriety by dint of sheer nastiness. He was factor and general lickspittle to the heid baddie, the Duke of Montrose and, in the film, is knifed and drowned in the loch. No such event took place in reality, but Graeme did take a few knocks at the hands of one Rob Roy who had become a trifle miffed at Montrose.

The little island which lies off Stronachlachar (the Point of the Mason) on Loch Katrine is where the feckless factor was held to ransom by Macgregor. The Duke was deeply unimpressed and refused to pay up, and Rob Roy simply got fed up and let Graeme go, unknifed and undrowned. If you want to take a close look at what is now known as Factor's Isle, treat yourself to a superb trip to Stronachlachar from Trossachs pier aboard the perjink little steamer, the SS *Sir Walter Scott*. The island was originally named Eilean Darrach, or Oak Tree Island, and has been built up to protect it from the raised levels of Loch Katrine.

Jimmie Macgregor

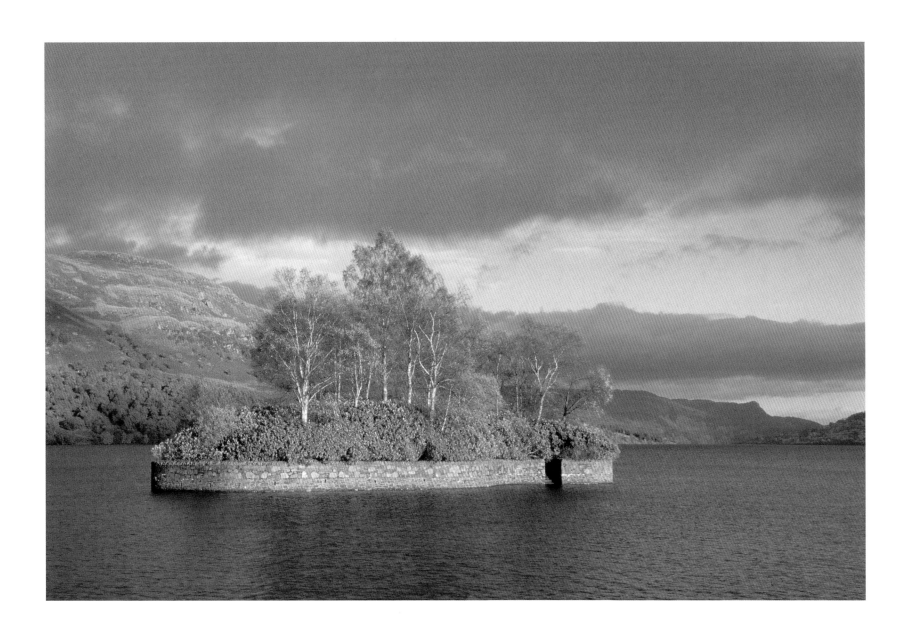

Suilven, Lochinver, Assynt

The favourite place of Dorothy Paul

I love Suilven because, when I was a girl, I had a cycling holiday up north and I remember going round a bend in a single-track road and being astounded to see this great mountain in all its glory.

I love the area in all its weathers and it surely can invite some rain and storm. Perhaps I am biased but I believe this is one of the most beautiful countries in the world. I say that, though, from my centrally-heated home. What must it have been like for the Picts!

Dorothy Paul

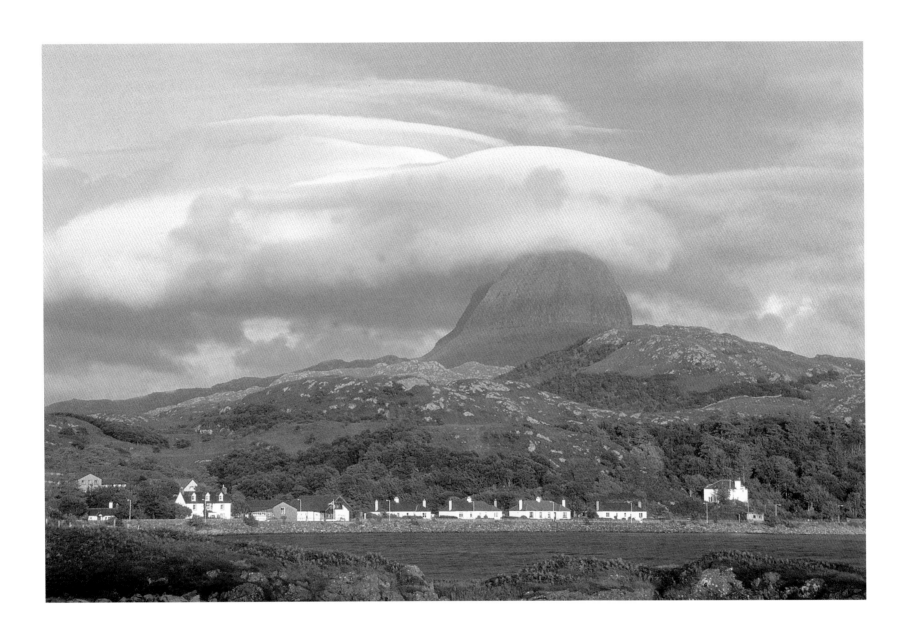

The Summer Isles, Achiltibuie, Wester Ross
The favourite place of Evelyn Glennie

The sheer desolation of this community of islands that form the Summer Isles stretches all my senses in ways that no other place can.

Each island is a gem, so full of life in the minutest but most precious way. They embrace the seasons that transform them into a kaleidoscope of colour, moods, texture and richness. The only predictable aspect is that nothing stays still, as seconds, minutes and hours transform the very way these islands breathe.

I'm completely transformed as I witness the ingredients of nature and its expansiveness as it tugs at the very heart of my being.

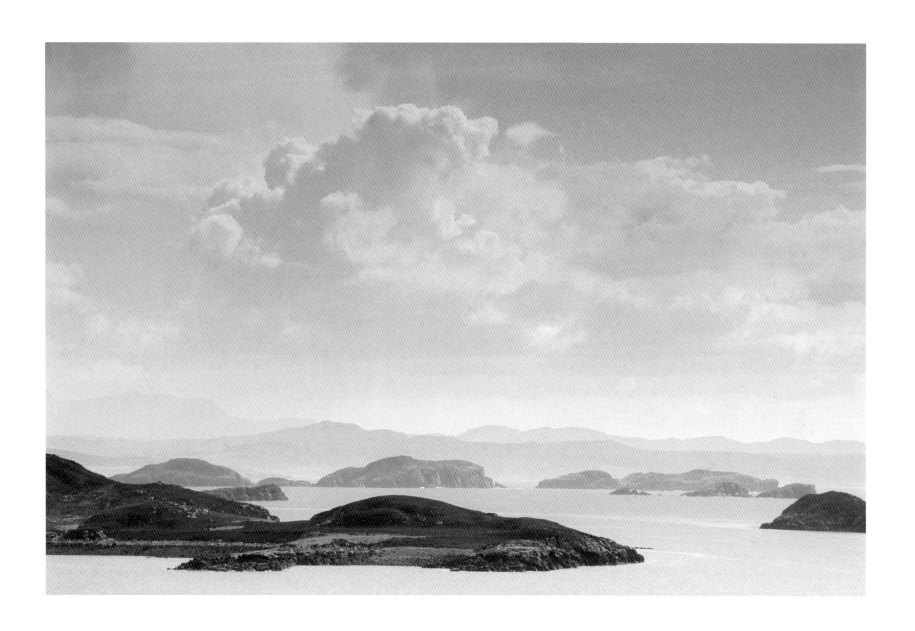

Uath Lochans, Glenfeshie, Badenoch

The favourite place of Cameron McNeish

There is a natural dynamic between forest and mountain, one that is generally sadly lacking in Scotland. Although many of the trees that surround Uath Lochans in Glenfeshie are exotic conifers, there is still a resonance of those ancient days when much of the Scottish Highlands was blanketed in forest.

The lovely lochans here often reflect the hills behind and their moods and colours reflect something of that special aura for which the Highlands are renowned.

In the lighting, Andy has certainly caught the magic of the Uath Lochans.

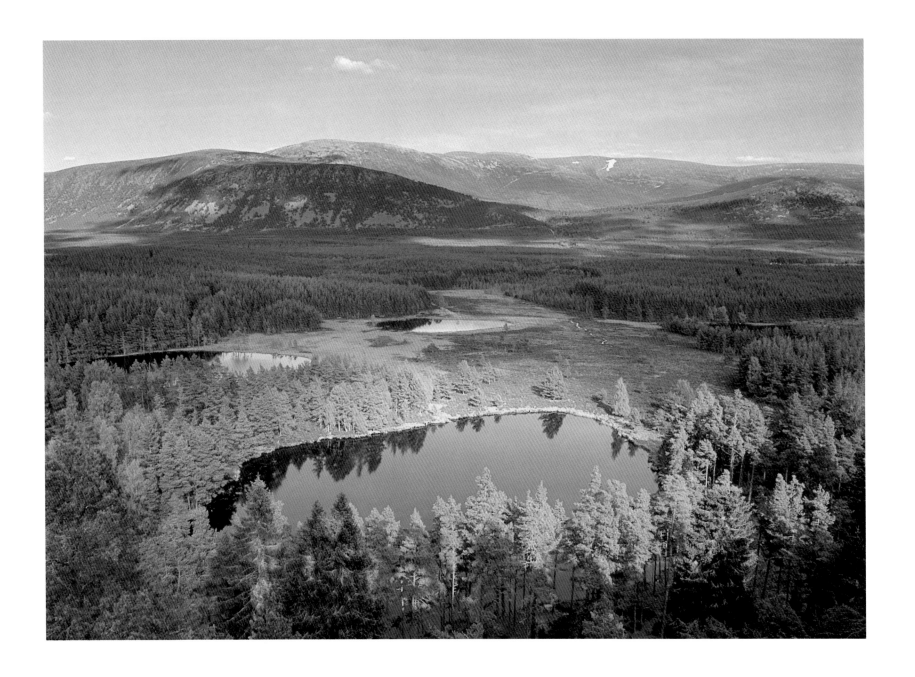

Ullapool, Wester Ross
The favourite place of Rikki Fulton

Ullapool, a name the Norsemen gave it, was founded in 1788. The very drive through to greet the scenery makes it worthwhile. Summer or winter, this little village maintains the warmth of the people who live here and will happily chat to you in English or the Gaelic.

One of our visits found us close to Loch Torridon to stretch our legs and we were visited by a brilliant rainbow which was bold enough to present itself and enter the driving seat of our car. But what matters when good luck comes!

My wife, Kate, and I have visited many times and look forward to further visits in that delightful village.

After all, you can't get higher than a rainbow!

Rikki Fulton.

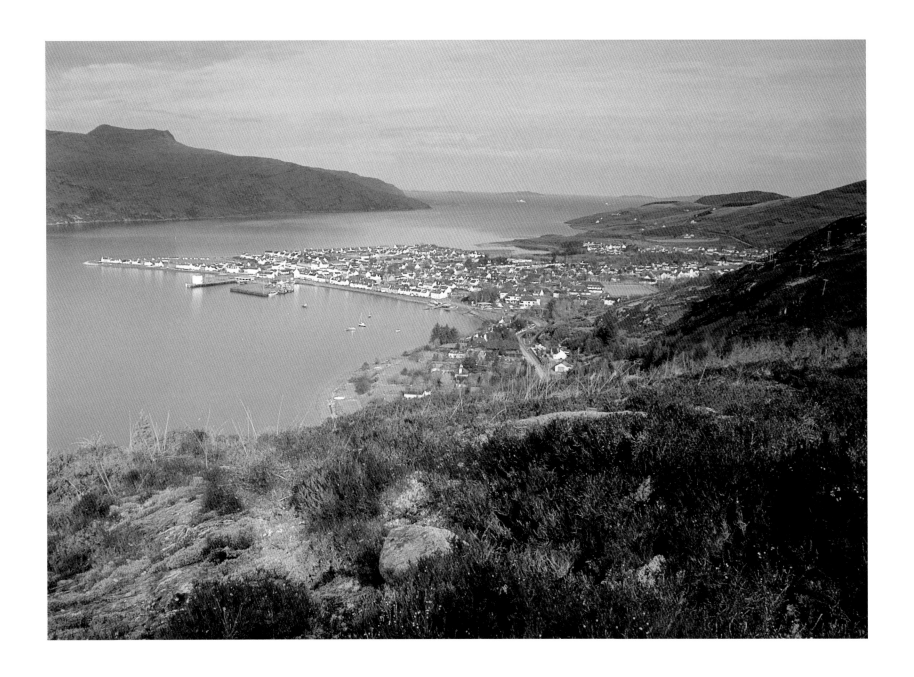

The West Sands, St Andrews, Fife

The favourite place of Hazel Irvine

The West Sands at St Andrews have been a special place for me ever since I was a student at University in the 'Auld Grey Toon'.

I went for long walks there with my friends and it was also a place I loved to experience on my own.

Whenever I am back in St Andrews, be it for work or pleasure, I always make time to stroll along the beach, look out to the sea and watch the town getting smaller on the horizon with every step.

Hazel Irvine

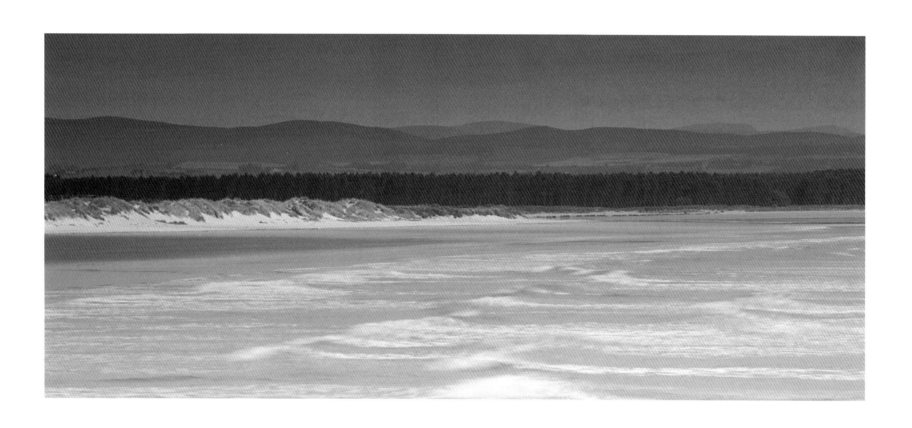

Tiroran, Isle of Mull

The favourite place of Andy Hall

Throughout the making of *A Sense of Belonging*, I have been asked about my own favourite place. Although I love Perthshire in autumn, Dunnottar Castle near my home town of Stonehaven and the mountains of the west coast in winter, I would say that Tiroran (the Land of Oran) on the Isle of Mull is the place for which I have a special affection. It was here that my mother was born in 1918 on an estate by the shores of Loch Scridain. More than anywhere else, it is here that I feel a sense of belonging.

When I look over the rocks, I can see my mother as a little girl playing in the rock pools with her sisters, Cathy and Bessie. Their home, America House (Tigh Ameireagaidh), was just yards from the sea, and as children they spent most of their time on the black, volcanic shores of the loch. The house itself had been transported from America and used originally as a community hall before becoming my mother's family home.

The girls loved combing every inch of the shore. Every Atlantic tide brought something new for them to play with. They decorated the rock ledges with bits of glass and china or anything that was colourful. No matter that the incoming tide washed down the shelves, they built them up again the next day.

One of my most treasured possessions is an account of their childhood written by my Aunt Cathy who stays near Bunessan on the way to the Iona Ferry. It is a very evocative description of the Tiroran of their childhood, not only of the people but also of the sights, sounds, smells and textures which seemed so abundant in their early years.

With a wonderful use of language that my mother also shared, she describes the carefree fun that they all had: the storytelling; walking to and from school in Scobul; watching out for fairies and snakes; the wild gentians, campanulas and the masses of white orchid by the wayside. She tells of their visits to Iona in a small open boat, soaked in seaspray and standing on the tiny island's hallowed ground with voices toned down to a whisper. I have visited Iona several times and can identify with that childhood experience.

My mother loved Mull, its landscape and its people. Despite moving to Perthshire in 1937, she held it always in her imagination. It is a beautiful island.

Andy Hall

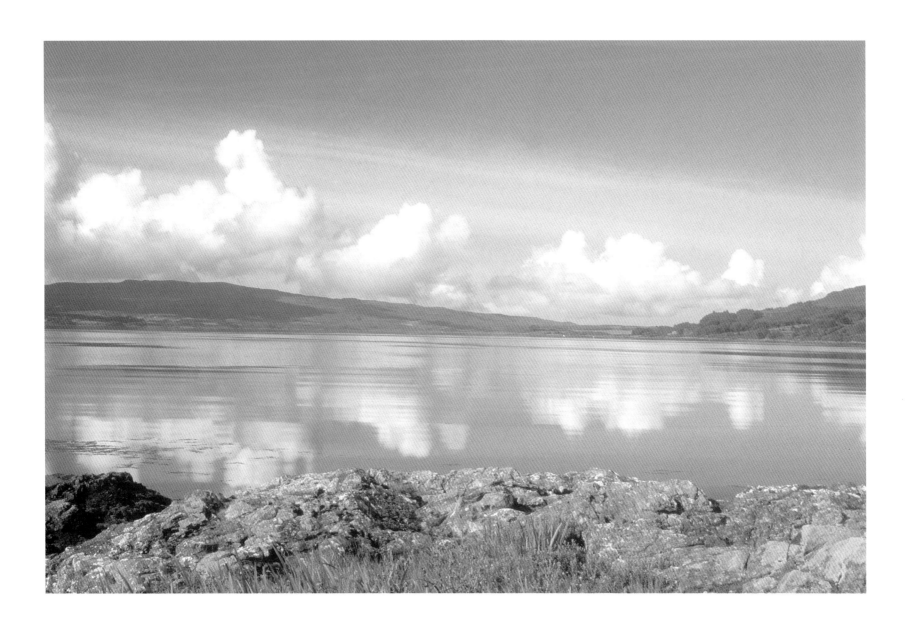

A Photographic Note

The landscape photographs in *A Sense of Belonging* were taken on Fuji Velvia 50 ASA (fine grain) slide film stock using a Canon EOS 650, single lens reflex camera, the first of the EOS range, first produced in 1987. The 650 was not on the market for very long before being replaced by the EOS 600, which had several improved features. My 650 has never let me down and always produces perfect metering. These reliable cameras can still be acquired on the pre-owned market.

The black and white portraits were taken on Fuji Neopan 400 ASA film stock and handprinted by Richard Connor ARPS, Stonehaven.

For the landscapes, I used a combination of three lenses: a Sigma 24mm ultra-wide angle, a Canon 28–80 zoom lens and a Canon 75-300 telephoto zoom. For the portraits, I used a Canon 100mm 2.8 lens, which is also an excellent macro (close-up) lens.

All the landscapes involved the use of a tripod, a Manfrotto 440 carbon fibre, which is excellent for stability and lightness. All shots were triggered using a cable release. Many of the shots were taken in low light and in order to get maximum depth of field or depth of focus, the equivalent shutter speed was well below the handholding threshold, necessitating the use of the tripod. For keen landscape photographers, I can't emphasise enough the need for a good tripod. Not only does it ensure sharp focus and the availability of full depth of field, it allows you to slow down and make the smallest of adjustments in framing and composition, which often makes the difference between a good shot and a great one.

I'm often asked about my equipment, and the fact that I use a fairly old camera which is relatively unsophisticated in terms of modern gadgetry refutes the notion that the equipment is the purveyor of atmospheric photography when in fact it is the 'seeing eye' which is the essence. Precise metering, lens quality and film choice are central elements in the process, but beyond that, the perfect image is achieved through a synergy of these technical requirements and the imagination and patience of the photographer.

On the completion of my first book, *The Mearns At The Millennium*, I received a William Blake quotation from Colin Prior which holds the key to successful landscape photography, notwithstanding the technical demands of the process: 'To the eyes of the man of imagination, nature is imagination itself. As a man is, so he sees.'

Biographies in Brief

KAYE ADAMS

Kaye was born in Falkirk and brought up in Grangemouth. She studied economics and politics at Edinburgh University. Her relaxed, professional and versatile presentation style has led to her involvement in a wide variety of programmes for the BBC, ITV, Channels 4 and 5 and STV. Her particular specialities are hosting audience discussion and debate programmes, conducting celebrity interviews and presenting and writing in-depth documentaries.

Her career began at Central Television in Birmingham, which she joined as a graduate trainee. During her four years at Central, she gained experience in news producing, reporting and political reporting but perhaps the highlight of her time there was a private audience with Margaret Thatcher at 10 Downing Street. The interview formed part of a half-hour special about women in politics which won two prestigious awards: 300 Group Best TV Programme and America's Women in Communications Vanguard Award.

In all, Kaye has won three Scottish BAFTA awards, one each for *Scottish Men* and *Scottish Women* and one for *Scottish Frontiers of Medicine*, for which she was also a finalist in the New York TV and Film Festival.

IAIN BANKS

Born in Dunfermline, Iain is one of Scotland's most successful contemporary writers. He was educated at Gourock and Greenock before studying at Stirling University. He had a variety of jobs before moving to London in 1979. During his time there he came to notice with his first published novel, *The Wasp Factory*, in 1984.

He has gone on to become one of the most acclaimed novelists in Scotland. He returned home in 1988 and since then he has produced fiction such as *The Bridge* in 1997, *Complicity* in 1998 and *The Crow Road*, which has been made into a successful TV drama. He also writes science fiction using his middle initial M (for Menzies). His latest science fiction title is *Look to Windward*.

He now lives in North Queensferry, overlooking the Forth Rail Bridge.

CRAIG BROWN

Appointed in 1993 as Scotland's National Coach and Director of Football Development, Craig was in charge of the national team on 70 occasions and had an outstanding record, losing only nine competitive matches. Before the appointment, he was Under-21 Coach and Assistant National Coach. Prior to joining the SFA staff, Craig was Manager of First Division Clyde FC for almost ten years, winning two league championships. Previous to the Clyde post, he was Assistant Manager at Motherwell for three years. He is presently manager of Preston North End.

In his playing days, Craig played for Rangers, Dundee and Falkirk before having his career curtailed by five knee operations. He has a Bachelor of Arts Degree and a Diploma of Physical Education. He holds Honorary Doctorates of the Universities of Paisley and Abertay, Dundee and was awarded a CBE in 1999. Prior to his involvement in full-time football, Craig was a headteacher and lecturer in primary education.

RONNIE BROWNE

Ronnie was born in Edinburgh in 1937. While at Edinburgh College of Art, he met Roy Williamson, who was later to become his partner in the hugely popular folk duo, the Corries. The Corries developed their own inimitable style of instrumental versatility, plaintive or rousing singing and entertaining delivery.

The song that they will always be associated with is Roy's 'Flower of Scotland', which has been adopted by thousands of Scots at home and abroad as Scotland's unofficial national anthem. Sadly, Roy died in 1990, but since then Ronnie has continued to entertain audiences in Scotland in a solo capacity.

RONNIE CORBETT

Born and educated in Edinburgh, Ronnie's career began in amateur dramatics. He is particularly noted for his highly successful and much-loved television comedy series, *The Two Ronnies*, with Ronnie Barker, a partnership which lasted for many years. In the early days he appeared with David Frost in the BBC series *The Frost Report* (1966–67) and *Frost on Sunday* (1967–68), later starring in the highly acclaimed series *Sorry*.

Ronnie was awarded an OBE in 1978.

BRIAN COX

Born in Dundee in 1946, Brian made his debut with Dundee Repertory Theatre before studying at the London Academy of Music and Dramatic Art. He is a highly experienced, respected and versatile actor and has played many Shakespearean leading roles including Titus Andronicus and King Lear.

Brian spends much of his time working in the United States, but he retains a strong affection for Scotland's east coast. His film roles include Trotsky in *Nicholas and Alexandra*, Killearn in *Rob Roy* and Argyle Wallace in *Braveheart*.

In 2001 he won an Emmy for Best Supporting Actor in *Nuremberg*. He is also an eminent writer and director and was the first British actor to teach at the Moscow Art Theatre School.

BOB CRAMPSEY

Bob was born in Glasgow in 1930 and has spent 45 years in broadcasting with both the BBC and ITV. He went to Holyrood Secondary School before achieving MA (Honours) in History at Glasgow University. He is an Associate of the Royal College of Music and an Honorary Doctor of the University of Stirling. In 1965 he was Brain of Britain and he reached the semi-final of *Mastermind* in 1973.

Although Bob has retired from regular broadcasting, he still contributes to football discussion programmes and writes about cricket in the Sunday press, particularly his beloved Somerset, whom he adopted in a time of need when he was stationed in the area.

His listeners regard Bob as the doyen of Scottish sports broadcasting due to his extensive knowledge and engaging style of presentation.

BARBARA DICKSON

Barbara is an actress and singer from Dunfermline. She has six platinum albums, eleven gold and seven silver. Her single, 'I Know Him So Well' (with Elaine Paige) sold a million copies. She has two Olivier Awards for *Blood Brothers* and *Spend, Spend, Spend*. She has been Scot of the Year and the Variety Club's Actress of the Year in a Musical.

Barbara was made an OBE in the 2002 New Year's Honours. She is married and has three sons.

SIR ALEX FERGUSON

Born in Govan, where he became an apprentice toolmaker in the shipyards, Sir Alex started playing football at senior level with Queen's Park. He went

on to play for St Johnstone, Dunfermline, Rangers, Falkirk and Ayr United.

He began his managerial career with East Stirling before moving to St Mirren, whom he steered to promotion to the First Division in 1977. He progressed to Aberdeen, where he won an unprecedented three league titles, four Scottish Cups and one League Cup and European Cup Winners Cup, beating Real Madrid in 1983.

He was lured to Manchester United in 1986. United won the 1990 FA Cup and, thanks to its success in developing young talent, the club went from strength to strength, winning seven Premiership titles, four FA Cups, one League Cup, a European Cup and a European Cup Winners Cup, for the second time in his career.

The 1998–9 season saw them winning a sensational treble—the English Premiership, the FA Cup and the European Cup. For his services to football, Sir Alex has been awarded a knighthood.

GREGOR FISHER

Born in Stirlingshire and brought up in Neilston near Glasgow, Gregor attended the Royal Scottish Academy of Music and Drama. His credits range from comedy to classical theatre and include *The Tales of Para Handy*, *The Railway Children*, *Nicholas Nickleby*, *Naked Video*, *Scotch and Wry* and *Rab C. Nesbitt*.

RIKKI FULTON

Rikki is one of Scotland's best-loved comedians and actors. Born in Glasgow, his early career was that of a series broadcaster for the BBC, while also appearing in repertory theatre. Since then he has adopted the role of Josie, playing against the late Jack Milroy's Francie, on television and on stage. His annual Hogmanay appearance on *Scotch and Wry* became an institution, especially his role as the melancholic minister, Reverend I. M. Jolly. His television appearances include *The Tales of Para Handy*. His films include *Gorky Park*, *Local Hero* and *Comfort and Joy*. In theatre, Rikki adapted and starred in *A Wee Touch of Class*, a successful transposition of Molière's *Bourgeois Gentilhomme* from seventeenth-century France to nineteenth-century Edinburgh. His autobiography *Is It That Time Already?* portrays a remarkable life in theatre, television and film.

He was awarded an OBE in 1992 and, in 1997, BBC Scotland's Broadcasting Council honoured him for 50 years with the BBC. In 1993, he received a Lifetime Achievement Award from BAFTA.

EVELYN GLENNIE

Evelyn was born in Aberdeen and brought up on the family farm in the north east of Scotland before attending the Royal Academy of Music in London. Listing her influences as Jacqueline du Pré and Glenn Gould, Evelyn was the first full-time solo classical percussionist in the world. She has performed in 40 different countries and spends up to four months of the year in the USA.

Evelyn has written and performed music for television, radio and film. In live performances she employs up to 60 instruments, giving around 110 concerts a year.

She gave the first ever percussion recital and percussion concerto in the history of the Royal Academy of Music. In 1989 she performed the first ever solo percussion Prom in London. She is co-director with Leonard Slatkin of a Percussion Festival in Washington DC.

Many awards have been bestowed on Evelyn, including two Grammy Awards, numerous Honorary Doctorates and an OBE.

HANNAH GORDON

Born in Edinburgh and trained at the Royal Scottish Academy of Dramatic Art in Glasgow, Hannah is best remembered for her television appearances which include *Upstairs, Downstairs*, *My Wife Next Door*, *Joint Account* and *Telford's Change*, as well as starring roles in *The Country Girl*, *An Ideal Husband*, *The Aspern Papers* and numerous other West End productions. Her film appearances include *The Day After The Fair* and *The Elephant Man*.

Hannah has her home in Surrey and her son, Ben Warwick, is also an actor. For the last four years she has presented the hugely successful painting programme *Watercolour Challenge* for Channel 4.

BUFF HARDIE

Buff is an Aberdonian, a graduate of Aberdeen and Cambridge Universities, who had a career as an Administrator in the National Health Service, culminating in his appointment as Secretary of the Grampian Health Board in 1976. In 1983, he left the Health Service and plunged into full-time show business as a writer/performer, specifically as one third of the comedy revue *Scotland the What?*, which for the next 12 years, from a home base of His Majesty's Theatre in Aberdeen, travelled regularly and successfully to all the major Scottish theatres and many of the minor ones.

The group retired in 1995, but in his retirement Buff has continued to contribute a weekly column (Dod 'n' Bunty) to the *Aberdeen Evening Express*.

GAVIN HASTINGS

Born in Edinburgh in 1962, Gavin completed his formal education at Cambridge University some 24 years later, after attending school at George Watson's College in Edinburgh and Paisley University.

Gavin's rugby achievements include playing in three Rugby World Cups as well as featuring in Scotland's historic Grand Slam side of 1990. He was captain of the British Lions in New Zealand in 1993. He also captained Scotland on 20 occasions, the most historic being their victory over France in Paris for the first time in 21 years.

Gavin retired from international rugby in 1995, having played for Scotland 61 times. Together with his six tests for the British Lions, he scored over 700 points. His contributions to his sport were acknowledged when he received an OBE in 1994 in the Queen's New Year Honours List.

He now runs his own marketing consultancy, Hastings International, based in Edinburgh, working on golf- and rugby-related projects as well as striving for the greater recognition of St Andrew's Day within Scotland.

STEPHEN HENDRY

Born in 1969 in Edinburgh, Stephen has achieved an unparalleled seven world titles in snooker. He was voted BBC Scotland's Sports Personality of the Year in 1987 and 1990, and in 1994 he was awarded an MBE. In June 2000 Stirling University granted him an Honorary Doctorate.

One of Stephen's most memorable performances came in the final of the 1997 Liverpool Victoria Charity Challenge. Having lost six successive frames that saw Ronnie O'Sullivan at his best, Stephen stepped up at 8-8 to clinch the match with a maximum 147 break.

Away from the tournament table, he still puts in four to six hours of practice a day and he relaxes by playing golf, often at Gleneagles near his home in Auchterarder.

HAZEL IRVINE

Hazel was born in St Andrews in Fife and she studied for an MA in History of Art at the town's university. Herself a talented sportswoman, she gained representative honours in golf, netball and athletics for Scottish Universities.

She joined BBC TV in 1990 as presenter of *Friday Sportscene* and has gone on to cover major events such as the Summer and Winter Olympics, the World Cup Finals and the Commonwealth Games. She is now a regular broadcaster for BBC Sport and BBC News.

At the 1999 RTS Awards she was named Best Regional TV Presenter/Reporter. She is the youngest person to have presented *Grandstand* and the first woman to front the network version of *Final Score*.

SIR LUDOVIC KENNEDY

Born in Edinburgh in 1919, Sir Ludovic studied at Oxford and served in the Royal Navy in the Second World War before becoming a lecturer and later editor of the BBC's *First Reading* in 1953. On television he hosted *This Week*, contributed to BBC's *Panorama* from 1960 to 1963, and from 1980 to 1988 presented the television review programme, *Did You See?*

He has also devoted himself to correcting miscarriages of justice. His books include *Ten Rillington Place*, *The Trial of Stephen Ward* and *A Presumption of Innocence*, about the case of Patrick Meehan. He published an autobiography, *On My Way to the Club*, in 1989, and was knighted in 1994.

DENIS LAWSON

Denis has worked extensively on stage, film and television, most notably in Bill Forsyth's *Local Hero*. His stage work has also included award-winning musical performances in *Pal Joey* and *Mr Cinders*.

Over the last three years, he has also begun to write and direct; his first stage production *Little Malcolm and His Struggle Against the Eunuchs* was in collaboration with his nephew, Ewan McGregor. He has just finished work on his second film, *Solid Geometry*, which he also wrote and directed with Ewan.

He lives in London with actress Sheila Gish.

JIM LEISHMAN

Jim was born in Lochgelly, Fife in 1953. A natural athlete, he was an outstanding footballer and youth golf champion at school before signing for Dunfermline Athletic in 1968.

He enjoyed a very successful career with the club both as a player and, later, as a manager. After spells as manager of Inverness Thistle and then Montrose, Jim became manager of Livingston Football Club. In May 2001, the club secured the coveted First Division Championship and subsequent promotion to the Scottish Premier League. Jim became the only manager in the history of the Scottish game to have taken two senior teams to the Premier League.

Affectionately known as the Bard of Lochgelly, Jim combines his managerial commitments with a successful career as an after-dinner speaker.

JIMMY LOGAN

Born James Short in Glasgow into a theatrical family, Jimmy's parents were the music hall act, Short and Dalziel. His Aunt, from whom he took his surname, was Ella Logan, star of Broadway musicals, and his sister became the jazz singer Annie Ross. He was educated at Gourock High School but left at 14 to work in the theatre. By 1944, he was in pantomime, his most enduring role.

His first acting role was in 1949 in *Floodtide*, a drama set in Clydeside. His show based on the life of Sir Harry Lauder proved a huge success, playing to packed houses in Portobello, Lauder's home town, as part of the Edinburgh Festival.

Other theatrical successes included *The Entertainer*, *Brighton Beach Memoirs*, *The Comedians*, *On Golden Pond*, together with a remarkable performance in *Death of a Salesman* at the Pitlochry Festival.

Jimmy was awarded an Honorary Doctorate by Glasgow Caledonian University and an OBE for his contribution to entertainment. He was also elected a Fellow of the Royal Scottish Academy of Music and Drama. Jimmy, who died in Clydebank in 2001, was one of Scotland's best-loved entertainers.

FRED MACAULAY

Born and brought up in Perthshire, Fred began his full-time career in comedy at the age of 31, making a dramatic move from his former occupation as an accountant. Fred regularly performed at the Edinburgh Festival Fringe and has toured extensively with his own stand-up show.

As well as having been involved in more than ten series on BBC Television in Scotland and the UK, he has hosted BBC Scotland's radio breakfast show since 1997.

Fred is in much demand for after-dinner entertainment and awards presentations throughout the UK and his work has also taken him to America, France, Hong Kong and Australia.

EILEEN MCCALLUM

Eileen was born in Glasgow, where she attended university and the Royal Scottish Academy of Dramatic Art. She has worked in television since the 1950s in dramas for the BBC's *Play for Today* by Peter McDougall and Lewis Grassic Gibbon, *Doctor Finlay's Casebook*, *Taggart* and several Hogmanay shows, but she is probably best known as Isabel Blair in *High Road*.

Her recent theatre appearances include *Olga* and *Lavender Blue* at the Royal Lyceum in Edinburgh, *Romeo and Juliet* with the Royal Shakespeare Company in Stratford and *Parking Lot in Pittsburgh* at the Byre Theatre in St Andrews. Films include *My Life So Far* and *Saved*, premiered at Edinburgh in 2001.

ALLY MCCOIST

Born in Bellshill in North Lanarkshire in 1962, Ally is one of the greatest goal scorers of his generation. He became Glasgow Rangers' leading scorer when, in 1997, he scored his 421st goal for the club. He was a key member of the team that won nine League Championships in a row beginning in 1988/9. He has been capped 61 times for Scotland.

Ally's career is now in television, where he is a team captain of *Question of Sport* and he also provides analysis in a variety of football programmes on ITV. As well as his halcyon period at Rangers, he has played for St Johnstone, Sunderland and latterly Kilmarnock.

MALKY MCCORMICK

Malky is Scotland's best-known cartoonist and his work has entertained millions of readers for over 30 years. He was born in Glasgow and after leaving the world of commercial art in 1965, he illustrated comics and magazines for D. C. Thomson in Dundee. Hr then became a graphic artist and designer with Scottish Television for three years. He is possibly best remembered for the hugely successful cartoon strip *The Big Yin*, which he devised with Billy Connolly.

Since then, he has contributed to most Scottish and UK newspapers and his work has illustrated several national advertising campaigns. His caricature skill has seen him invited to corporate events in Jamaica, Canada, Croatia, Germany, Romania, Kuwait, India and Russia. For ten years, he was resident cartoonist on ITV's networked quiz show, *Win, Lose or Draw*. Malky is much sought after as an after-dinner speaker where he draws lightning sketches of his audiences.

EWAN MCGREGOR

Ewan was born in Crieff in Perthshire. He became an actor at an early age, starting out in Perth Repertory Company, then studying at Fife College in Kirkcaldy. Though Ewan was a fan of James Stewart, the prime influence on his career choice was his uncle, Denis Lawson. He spent three years in London, studying at the Guildhall School of Music and Drama. Television success arrived almost immediately after leaving the Guildhall when he took a lead role in Dennis Potter's *Lipstick On Your Collar*.

He came to film prominence in *Shallow Grave* in 1994 and with the Oscar-nominated *Trainspotting* in 1996, portraying Edinburgh's drug culture. He starred, to much acclaim, with Nicole Kidman in the spectacular *Moulin Rouge*. Over the years, in two Star Wars films playing Obi Wan Kenobi, in *Black Hawk Down* and *Young Adam* (the latter set in his native Scotland), Ewan has demonstrated an incredible versatility in the roles he has taken on.

In 2001, Ewan received an Honorary Doctorate from the University of Ulster.

JIMMIE MACGREGOR

A graduate of Glasgow School of Art, Jimmie was influential in the early days of the folk revival in Britain and enjoyed a highly successful 20-year career with his partner, Robin Hall.

He has written a number of books based on his long-distance walks programmes for radio and television and has twice been named Scot of the Year. A Fellow of the Royal Zoological Society of Scotland, he was awarded an MBE in the 1994 for his services to Scottish heritage and culture. His highly successful daily radio programme, *Macgregor's Gathering*, ran for more than ten years.

As well as making videos on *The West Highland Way*, *In the Footsteps of Bonnie Prince Charlie* and *Rob Roy Country*, Jimmie also now presents a series of illustrated lectures based on his travels.

SIR CAMERON MACKINTOSH

In 1998 Cameron celebrated 30 years as a musical producer with an extensive list of successes behind him, including *Song and Dance*, *Les Misérables*, *Phantom of the Opera* and *Miss Saigon*.

In 1980 Andrew Lloyd Webber suggested that they should work together. Their first joint venture, *Cats*, which opened at the New London Theatre in 1981, became the longest-running musical in the West End in 1996, and in 1997, it became the longest-running show in Broadway history. In July 2001 his production of *My Fair Lady* opened at the Theatre Royal, Drury Lane, with a record box office advance.

Sir Cameron was knighted in 1996 for his services to the British Theatre.

DOUGIE MACLEAN

Born in Perthshire in 1954, Dougie grew up in the countryside, where his father was a gardener. He was surrounded by his family's love of music. His early musical years were spent touring all over the UK and Europe as a member of the Tannahill Weavers, playing fiddle and sharing vocals, then subsequently touring and recording with Alan Roberts, Alex Campbell and Silly Wizard.

Since 1982, when he launched his solo career, Dougie has built an international reputation as a songwriter, composer and performer. His albums have attained gold disc status, his songs have been covered by hosts of artists and his 'Caledonia' has become one of Scotland's most popular contemporary songs. His music has been used in television drama and in Hollywood films such as *Last of the Mohicans*. He has also been the subject of three BBC TV music documentaries.

Along with his artist wife, Jennifer, this energetic man also has an independent record label, a recording studio, a publishing company and a hotel, MacLean's Real Music Bar at the Taybank in Dunkeld, which has been described as 'Scotland's Musical Meeting Place'.

BILLY MCNEILL

Billy was born in 1940 in Bellshill, Lanarkshire. He joined Celtic from his local junior team, Blantyre Victoria, in August 1957.

His most prolific days at centre-half and captain were under Jock Stein. Celtic reached the pinnacle of their success in May 1967, when Billy had the honour of being the first British footballer to hold aloft the European Cup after defeating Inter Milan in the Stadium of Light in Lisbon.

Billy was capped 29 times for Scotland, 5 of these at under-21 level. He also collected seven Scottish Cup-winner's medals, amassing over 800 appearances for Celtic.

In 1976 he was awarded an MBE and he went on to manage Clyde, Aberdeen, Celtic (twice), Manchester City and Aston Villa. He now appears regularly on television as a football analyst.

CAMERON MCNEISH

Cameron is one of Britain's best-known outdoor commentators. As editor of *TGO*, *The Great Outdoors* magazine, he is frequently called upon to offer opinion and comment on environmental matters.

A keen mountaineer, backpacker and skier for over 30 years, Cameron has climbed and walked in some of the world's most challenging places. He is President of the Ramblers' Association in Scotland and has written extensively on outdoor matters in books such as *Scotland's 100 Best Walks* and *The Wilderness World of Cameron McNeish*.

SALLY MAGNUSSON

Born in Glasgow, Sally began her journalistic career on the *Scotsman* and went on to become one of the BBC's leading news presenters. She currently anchors the BBC's early evening news programme, *Reporting Scotland*, presents *Hard Cash* and *Songs of Praise*, and reports for *4x4*.

As well as working on a range of television and radio programmes, Sally has won both newspaper and television awards including a Scottish BAFTA for *Dunblane Remembered* and an RTS Award for her exclusive interview with Earl Spencer entitled *Diana, My Sister*. She is the author of books on Eric Liddell, the Scottish athlete, and Jack Clemo, the deaf and blind Cornish poet. Her latest is *Family Life*, a hilarious account of her life as a working mother of five.

MICHAEL MARRA

Michael was born in Lochee, Dundee in 1952. He is one of Scotland's most talented original songwriters and performers.

In 1971 he formed his first band, Hen's Teeth, whose line-up included Dougie MacLean. By the mid '70s, he was a professional musician in Skeets Boliver with his brother Christopher.

Since then, he has worked in theatre and television, writing and recording soundtrack music, and notably acting as musical director for the acclaimed BBC production of John Byrne's *Cheatin' Heart*.

Alongside his theatre work, Michael has continued to perform and record as a solo artist as well as with poet Liz Lochhead.

DONNIE MUNRO

Donnie was born on Uig on the Isle of Skye. A graduate of Gray's School of Art in Aberdeen, he taught art in Inverness, Skye and Edinburgh before becoming a professional musician with Runrig.

The band surpassed all Scottish records for live performance, playing major venues such as Loch Lomond, Stirling Castle and Edinburgh Castle. Seven Top 40 singles and four Top 20 albums have ensured a hugely popular national and international profile.

No longer with Runrig, Donnie released his first solo album in 1999. Since then, he has released his highly acclaimed *Across the City and the World* album and performed extensively throughout Germany and Scandinavia. Donnie continues to work as a visual artist, exhibiting regularly through Edinburgh's Scottish Gallery.

Having already served as Rector of Edinburgh University from 1991–94, Donnie is now Rector of the University of the Highlands and Islands and is Director of Development with Sabhal Mór Ostaig in Skye. Edinburgh University honoured him in 1994 when he became Doctor Honoris Causa.

NICK NAIRN

Nick was born in Port of Menteith, near Stirling, and educated in Callander. After leaving school, he joined the Merchant Navy as a Navigation Officer. Travelling the world awakened a passion for food and on his return to Scotland he took up cooking for himself. His first restaurant, Breaval, opened two years later.

Presently, Nick is the proprietor of Nairn's restaurant in Glasgow, owns Nairn's Cook School on Lake of Menteith and has an events company, Nairns Anywhere. He has filmed three successful television series with the BBC including *Island Harvest* and appears regularly on food programmes such as *Ready, Steady, Cook* and *Food and Drink*. His twelfth book, *New Scottish Cooking*, was published by the BBC in 2002. Nick is an avid promoter of Scottish produce and is involved with the Scottish Executive in helping to increase awareness of healthy eating.

DANIELA NARDINI

Daniela was born and raised in Largs and went to Largs Academy. She studied at Edinburgh School of Acting before attending the Royal Scottish Academy of Music and Drama in Glasgow from 1986 to 1989.

In a very successful career in theatre, television and film, Daniela has shown great versatility, from playing the main role of Mary in Liz Lochhead's *Mary Queen of Scots Got Her Head Chopped Off* at the Royal Lyceum in Edinburgh, to the central character of Anna in *This Life* for BBC2.

Among Daniela's achievements are the Citizens' Theatre Award in 1989, the BAFTA Award for Best Actress in 1998 and the Broadcasting and Press Guild Award for Best Television Actress in 1998. For Anna in *This Life* she gained a Scottish BAFTA in 1997.

BILL PATERSON

Bill was born in Glasgow and began a career as a quantity surveyor before attending the Royal Scottish Academy of Music and Drama. His first professional appearance was with the Glasgow Citizens' Theatre in their 1967 production of Brecht's *The Resistible Rise of Arturo Ui*, which also launched the career of Leonard Rossiter.

He was a founder member of John McGrath's 7:84 Scotland Theatre Company and has made many appearances at the National Theatre, the Royal Court and in the West End.

As well as theatre, Bill has worked extensively in film and television. His films include *The Killing Fields*, *Comfort and Joy*, *The Witches*, *Truly, Madly, Deeply* and, most recently, *Crush*. Television includes *Smiley's People*, *The Singing Detective*, *Auf Wiedersehn Pet*, *Traffik*, *The Crow Road*, *Wives and Daughters* and, most recently, *Zhivago*. His voice is familiar from the narration of many documentaries.

DOROTHY PAUL

Comedienne and raconteuse, Dorothy was born in Dennistoun in Glasgow. Famous for her humorous observations from her childhood and her impersonations of Glasgow characters, she began in theatre after winning a talent contest.

She has a career-long history of playing pantomime and is fondly remembered for her starring role in *Aladdin* at Edinburgh's Palladium Theatre in 1957, before continuing into variety with other Scottish comedy stars such as the late Jack Milroy and Johnny Beattie.

Dorothy joined Scottish Television's *One o' Clock Gang* in 1959 and among her more recent successes are *The Celtic Story* and the wonderful Tony Roper portrayal of the lives of a group of Glasgow women, *The Steamie*. From 1991 she has performed in five successful one-woman shows including *The Full Dorothy* and *Now That's Her, Now That's Her Again*. Recently, she has written and appeared in her first play, *A Happy Medium*, which was co-written and directed by John Bett.

IAN RANKIN

Born in Cardenden in Fife in 1960, Ian was educated at Beath High School and Edinburgh University. At school, his poetry won several prizes. At university, Ian turned from poetry to short stories, again winning several literary awards. After embarking on a PhD studying Muriel Spark, he went on to write a series of bestselling crime novels featuring Detective Inspector John Rebus.

Ian was awarded the Crime Writers' Association's Gold Dagger Award for the best novel of 1997 for *Black and Blue* and by 1999, he had ten of his books in the Top 20 Scottish bestsellers list. Edinburgh University made him Alumnus of the Year in the same year. He was awarded an OBE in the Queen's Jubilee Honours in 2002.

EDDI READER

Eddi was born and brought up in Glasgow. After early busking experiences from Sauchiehall Street to Europe and as a backing singer for The Eurythmics and Alison Moyet, she came to the attention of a wide audience as the singer with Fairground Attraction. The song 'Perfect' and the parent album *First of a Million Kisses* both topped the British charts. Since then she has produced many albums, most recently *A Simple Soul*, which conveys her beautiful voice and songwriting versatility at its best.

CAROL SMILLIE

Carol was born in Glasgow and went to Hutcheson's Grammar School before studying Fashion at Glasgow School of Art. She began her career as a model and got her first television job on *Wheel of Fortune*. Since then she has worked on the *Travel Show* and *Holiday* before becoming very successful with *Changing Rooms*, one of the first home improvement shows.

GORDON SMITH

Currently a football analyst for Radio Scotland and BBC TV, Gordon has appeared regularly on *Saturday Sportscene* since 1997. He is also a regular newspaper columnist. A licensed football agent, he now operates his own sports management company.

His football playing history is wide and varied. A professional player for seventeen years, he played for Kilmarnock, Rangers, Brighton, Manchester City and Oldham, finishing his career in Austria and Switzerland.

Gordon is a business graduate and speaks fluent German from his time playing abroad.

SIR DAVID STEEL

Sir David was born in Kirkcaldy and studied at Edinburgh University, where he later became Rector. He became the youngest MP in 1965, representing the Borders constituency of Roxburgh, Selkirk and Peebles. Leader of the Liberal Party from 1976 to 1988, he was knighted in 1990. In 1999, Sir David, or Lord Steel of Aikwood, became the first Presiding Officer of the new Scottish Parliament. He is also an eminent author, his books including his autobiography, *Against Goliath*, and *Mary Stuart's Scotland*.

SAM TORRANCE

Sam was born in Largs in Ayrshire and raised in Lancashire before returning to his birthplace as a teenager. He became a professional golfer in 1970 and has enjoyed significant success. Of his Ryder Cup matches, his win at the Belfry in 1985 is his most memorable. He is presently Captain of Europe's Ryder Cup Team. For his services to golf, Sam was awarded an MBE in 1985.

KIRSTY WARK

Kirsty was born in Dumfries and educated in Kilmarnock and Ayr. Now based in Glasgow and London, she is one of Scotland's most respected television presenters.

As BBC Scotland's main presenter on all its political programmes and election specials, Kirsty has interviewed many top politicians, but her most memorable interview was in 1990, when she conducted a headline-making interview with the then Prime Minister, Margaret Thatcher.

In the late eighties she presented BBC's *Breakfast Time* and *The Late Show* before joining BBC2's flagship current affairs programme *Newsnight* in 1993.

Rough Justice signed Kirsty as presenter in February 1998. She is also involved in Arts programmes for the BBC, and through Wark-Clements, the leading independent production company, she has presented a series on Scottish architecture, *Building a Nation*, and *From Here to Modernity* on the British modernist movement. Her most recent documentary series was *Lives Less Ordinary*, made by her company for BBC Scotland.

In 1997 she won the BAFTA Scotland Best Television Presenter Award.

JONATHAN WATSON

Born in Glasgow, Jonathan trained at the Royal Scottish Academy of Music and Drama. On leaving college he joined the Glasgow Citizens' TAG Theatre Company and went on to work with the Traverse, Borderline, 7:84, Royal Lyceum, Perth Rep., and the Scottish Theatre Co., while returning to the Citizens' on many occasions.

While he featured in many television dramas earlier in his career, it was his involvement with BBC Scotland's Comedy Unit that brought him to the public's attention.

He is best known for his satirical look at Scottish football, *Only an Excuse?*, which has become a much-anticipated feature of BBC's Hogmanay schedule. The show has also enjoyed great success when transferred to the stage.

JACK WEBSTER

Born in 1931 in the village of Maud, Aberdeenshire, Jack fulfilled a boyhood dream by becoming a journalist. Starting at the age of 16 with the *Turriff Advertiser*, he later moved on to the *Aberdeen Evening Express* and the *Press & Journal* before moving south to join the *Scottish Daily Express* in Glasgow. After a highly successful career as a features writer with the *Express*, he became a popular columnist with *The Herald*.

As well as working in newspapers, Jack has written fourteen books, including his evocative autobiography *Grains of Truth*, biographies of Alistair MacLean and Reo Stakis as well as *The History of Aberdeen Football Club*.

Jack gained BAFTA awards for his BBC television classic, *Webster's Roup*, and for his nostalgic return to Buchan, *Walking Back to Happiness*, produced by Grampian Television. Despite being retired from the newspaper world, he remains extremely busy producing diverse and entertaining books.

RICHARD WILSON

Richard was born in Greenock and worked as a research scientist before training at the Royal Academy of Dramatic Art in London. He is particularly loved for his award-winning portrayal of the irascible character Victor Meldrew in the television series *One Foot in the Grave*. Other TV work includes *Tutti Frutti*, *Only When I Laugh* and *High Stakes*.

In 1994, Richard was awarded an OBE for services to drama as a director and actor. From 1996 until 1999, he was Rector of Glasgow University. He is an Associate Director of the Royal Court Theatre.

KIRSTY YOUNG

Kirsty is one of the country's top newscasters. She was born in Glasgow in 1968 and began her journalistic career in 1989 as a newsreader for Radio Scotland, where she also presented the *Drivetime* show. In 1992 she moved to Scottish Television where she was the presenter of *Scotland Today*. From 1994–95 she was the host of *Kirsty*, a bi-weekly live discussion programme on STV.

After credits with BBC and ITV, Kirsty fronted *Channel 5 News*, which she presented from its launch in March 1997. Kirsty returned to Channel 5 in January 2002 as the station's main news anchor after two years in ITN's ITV newsroom where she presented *News at Ten* and the *Six-Thirty News*.

During her time at Channel 5, Kirsty has won the Newscaster of the Year Award in 1998 and the prestigious Sir James Carreras Award for Outstanding New Talent of 1997.

The Last Word

My aim at the outset of this project was to photograph the chosen places in a way that would do justice to the feelings of affection of the people involved. In a photographic sense, I feel that I have achieved what I set out to do. *A Sense of Belonging*, however, has been about more than the photogenic qualities of the locations. Although my task has been to elicit the essence of the places, the personalities' writing has revealed a much deeper dimension than I ever envisaged at the beginning. The photographs have provided the key to a rich casket of memories and associations, hitherto unrevealed.

I have been given the opportunity to meet many interesting people while, at the same time, being able to capture Scotland at its most diverse and radiant. I owe a debt of gratitude to all the people who have allowed me to indulge my passion for Scottish landscape photography and to realise a dream.

I have met many people who have been extremely friendly and helpful. It would be unfair to single anyone out from all the examples of kindness that have been shown to me, but I would like to make one exception with Carol McGregor, Ewan's mother. From the outset, Carol couldn't have done enough to help me. She even walked with me, on a miserable day of rain, alongside the River Earn to show me the favourite place of her actor brother, Denis Lawson. Carol's willingness to facilitate communications and the friendliness of the whole family means a great deal to me.

The dedication of *A Sense of Belonging* to Jimmy Logan has given me a great sense of privilege. Jimmy was very supportive of the project and, as you can read on page 16, he wrote a lovely piece about Dunkeld and its connections with his father. When Jimmy died in April 2001, I wrote to his wife, Angela, and asked if she would permit me to dedicate the book to his memory and the wonderful contribution he made to Scotland's theatrical culture. I am delighted that she agreed so readily.

I hope you have enjoyed this photographic journey through Scotland, and most of all, that you visit and revisit your own special place, even if only in your imagination. I remember in the early days that I got a phone call from Rikki Fulton in reply to a letter I had sent. As you have seen, Rikki's favourite place is Ullapool and he said that even if it was a dull, grey, rainy day in Glasgow, he would imagine himself 'under an Ullapool sky'. The evocative simplicity of this idea has stayed with me throughout the making of the book.

Late one winter evening, I happened to be browsing through a hand-written notebook that had belonged to my late mother, Isa, whose mind's eye was never far away from her native Isle of Mull. It was dated 31st May 1940 and it contained pieces of verse that she had been moved to write down during the dark early years of the War. Among these verses, I came across the following lines that seemed to crystallise, in a few beautifully lyrical words, the essence of all those special places that reside in the imagination and memory. There was no indication of the writer's name so I can't give credit. I am indebted to that person's creative inspiration.

> *There is a garden in the mind*
> *Where memories grow.*
> *Where the grass is ever green*
> *And not a single flower blooms*
> *To fade or die.*